Travel Photography
MASTERCLASS

Joe Cornish • Charlie Waite • David Ward • Ben Osborne • Paul Harris • Niall Benvie
Phil Malpas • Clive Minnitt • Edited by Ailsa McWhinnie

ARGENTUM

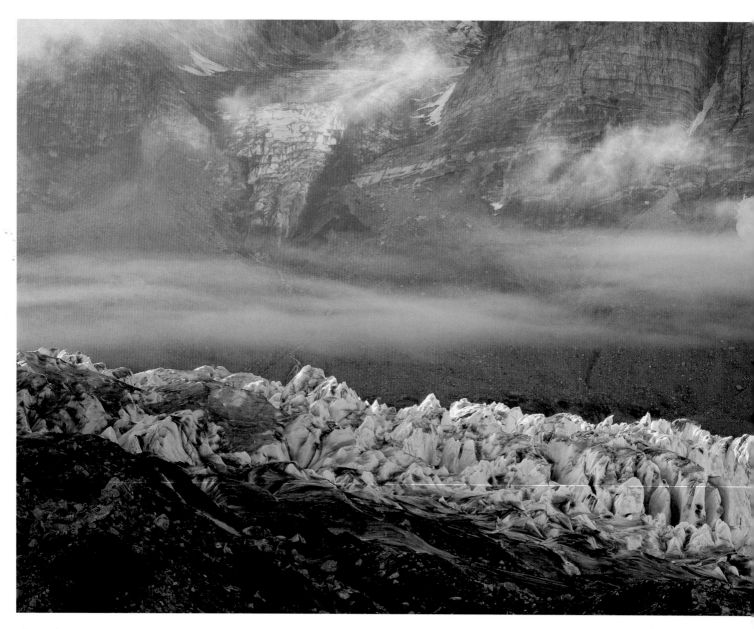

Glacier | Ben Osborne

PREVIOUS PAGE: **Gordes, Provence** | David Ward

CONTENTS

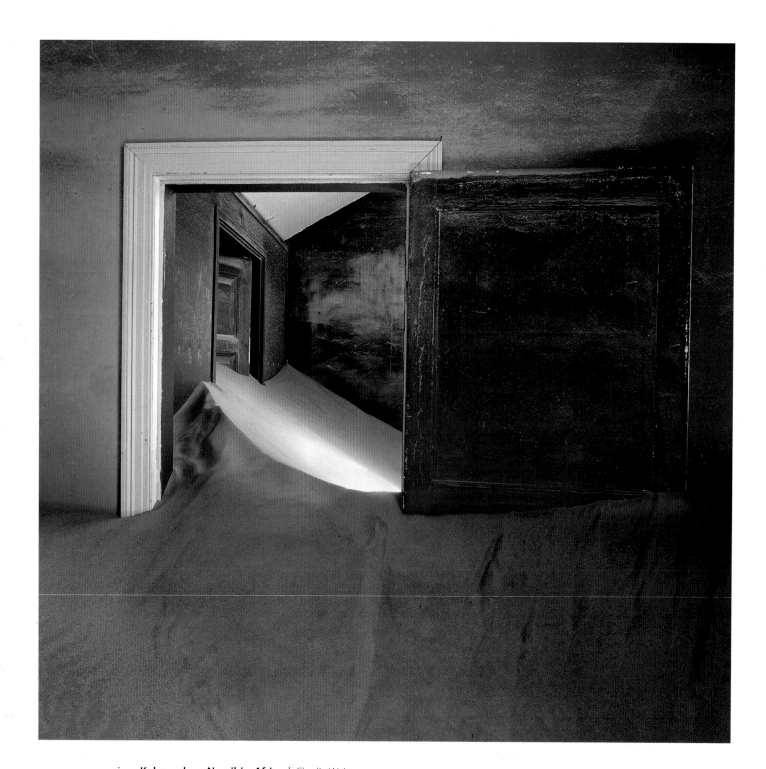

Kolmanskop, Namibia, Africa | Charlie Waite

This image is about several things. Firstly, there is the tension between the cold, blue tones and the warmer yellow. Then there is the geometry of the composition, which is softened by the sea of yellow sand dunes. Finally, there's a hint of a *trompe l'oeil* in the background, where it's difficult to tell whether it's flat or has depth. For me, the weird arrangement of shapes culminates in that far corner. It's hard to believe this was once somebody's living room.

Introduction

The nature of travel

We live in an age where anyone with a decent camera and a passport can call themselves a travel photographer. The world has become incredibly small in recent decades, with few corners inaccessible to those determined enough to reach them. And nothing is more natural than the desire to record one's travels – to produce images that declare 'I was there.' Yet there is so much more to travel photography than a few hastily composed snaps which, more often than not, say little more than that the person behind the lens wasn't there at the right time for successful, compelling photography.

Many of us will relate to the disappointment of the pictures not living up to the experience of travel – so what can be done about this? For many, it's a case not of going to a place and taking a few pictures, but of going somewhere *because* of photography: allowing the compulsion for making images to lead you to a location, and to interpret it in a manner that not only does justice to the place, but also to the photographer and his or her observational skills. This can only be achieved by entrenching yourself in both image-making and in the location itself. Revealing how to go about this is what we hope to achieve with this book.

Travel Photography Masterclass is divided into four chapters: Landscape, People, Architecture, and Wildlife. Each chapter features interviews with two professional photographers, and a gallery by individuals who have travelled to destinations worldwide in order to interpret them in their own way. Despite this chapter division, there is inevitably some crossover: a building sits within the landscape, and people use a building, work the landscape or share their environment with the local wildlife. What

is suggested, perhaps, by dividing the book in such a way is that it can pay dividends to concentrate on just one or two of these disciplines on each trip, to immerse yourself in making images on a particular theme – to create a body of work that best represents a specific aspect of that place. And if this means returning home with fewer images, so be it. Far better, surely, to have missed a few photographic opportunities, but be satisfied with what you did capture, than to frantically record everything witnessed, only to be dissatisfied with most of the results.

If there's one cast-iron guarantee in photography it's that those involved in the profession won't agree on everything – or indeed, in some cases, anything! As such, some of the advice contained in one part of this book might appear to be in conflict with the opinion expressed in another. If this demonstrates anything, it's that what works for one photographer, doesn't for another. In photography there are few rights and wrongs.

This book is not an attempt to show the reader 101 ways to improve their holiday pictures. In fact, the photographers who feature in these pages probably wouldn't describe themselves as 'typical' travel photographers at all. However, they are experts in their fields, and their work takes them overseas frequently. As such, they are well qualified to offer their opinions and experiences for others to learn from, be that in the area of making the most of a location on limited time; overcoming challenges in terms of light, timing and composition; and researching – or not – destinations in advance. Above all, their experiences allow them to keep their eyes and minds open at all times in a location – be it new or familiar. They are confident enough to challenge themselves creatively, hopefully avoiding predictability as a result – and ultimately making images that are true to themselves. After all, isn't that what all photography should be about? Not to simply say, 'I was there', but, 'This is how I saw it.'

Ailsa McWhinnie
Editor, *Travel Photography Masterclass*

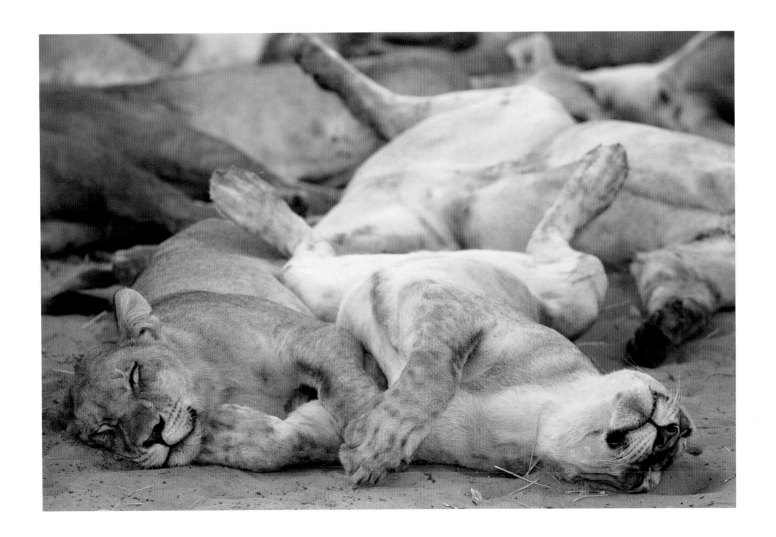

Sleeping lionesses, Chobe National Park, Botswana | Ben Osborne

We followed this pride of lions day and night for a month. They hunt at night, and sleep profoundly during the day, but sometimes that can make for interesting images. On one occasion we were chatting, and none of us noticed the 30 of them waking up and disappearing. It took us a while to find them again…

CHAPTER 1 : **LANDSCAPE**

A little bit of light fell on the land | Clive Aldenhoven
(See page 154 for technical details)

Don't take anything for granted
The natural world can constantly surprise us. We should never become complacent or blasé about its wonders.

Yosemite skyline | Brian Clark
(See page 154 for technical details)

Introduction

In many ways, it is the landscape that defines a country. Mountainous regions tend to be filled with drama and sparsely populated, with innovative farming methods deployed in the accessible areas to ensure the population's survival. A coastal area is different again, given character by the sea's impact on, and relationship with, the land. Flat regions are often windswept – and notoriously difficult to photograph in all but the most impressive light. While soft, undulating landscapes capture glorious variations of light and shade in their billowing forms.

Interpreting the landscape is nothing if not a personal choice, and finding new ways to capture popular destinations in a creative, sensitive manner is one of the ongoing challenges of photography. Opening the mind to the possibilities of a location can be overlooked amid the excitement of being in a new place, but the essence of that location can be conveyed in many ways. Keep in mind that a close-up of the landscape can speak as eloquently about the 'personality' of a wild place as a spectacular composition that takes in foreground, distant detail and dramatic sky. **AMc**

DAVID WARD

A sense of the unexpected

While I would never presume to call myself a travel photographer in the traditional sense – in that I don't go overseas to tell photographic stories about a particular culture or people – the vast majority of my photography takes place away from home. Quite simply, this is because it always takes me a day or two to get into the receptive frame of mind I need to make images, and the motivation to find this time is hard to come by when I'm immersed in my home life. You might say that I'm a travel photographer only inasmuch as many of the places I'm interested in photographing are outside the UK.

The element of surprise

I travel because I need to feel as if I'm on the edge of a new visual experience – in other words, I need to be surprised by things. For me, travel is an important part of that process. The easiest way of putting myself in a mental space where I'm receptive and able to achieve that visual naïvety is to go somewhere I don't know. In familiar places it can be difficult to avoid falling into expected patterns, and to stay within my comfort zone. Travel is one way of preventing that. This isn't to say that I always want to go somewhere new. I do revisit places and, although it might appear to contradict the argument I've just put forward, I often make more interesting pictures on the second visit. The reason is because there might be a two- or three-year gap between trips to a particular place, and my photography will have moved on. As a result, I find myself making images I won't even have seen on my first visit. So a degree of familiarity with a location is a good thing, but if you become too familiar with a place it's hard to make images that are original.

Be your own worst critic

All landscape photography, wherever it takes place, is a question of resolving the problem of composition. There are thousands – maybe even millions – of solutions to this problem. So the longer you take the more likely you are to come up with something novel. Even though I always take my time I am still ruthlessly critical of my work. It seems to me that the best way to avoid complacency and falling into predictable patterns is to be constantly dissatisfied with your output! Of the 350 or so images I make each year, I probably like 25. Two or three years later I might like only five of those – maybe even fewer.

Shooting 5 x 4 in, as I do, necessarily means making fewer images. People often ask if I'm missing out on opportunities because the process is so slow. They might as well ask if I'm missing out on making images in Japan because I'm not there right now. There are always countless opportunities for photography, wherever one might be, but rarely are there the opportunities to make an exceptional image. I would rather make a few images and invest as much time and effort as I possibly can in each. Then, some might turn out to be great. Fifteen images that I'm happy with from a two-week →

Tungenset, Norway
David Ward

This is one of the few places in Norway that's a 'viewpoint'; it even has a ramp that leads down to the shore, which is carved with pools and sweeping lines, and has a fantastic peninsula in the background with fairytale mountains. I shot this scene at 1am in early August. As it's inside the Arctic Circle on the edge of the Arctic Ocean, the sky tends to be either completely covered in cloud or clear. You might catch the edge of a sheet of cloud if you're lucky. I used a 5.5-stop ND grad – and my meter was still telling me the sky would be overexposed, but as Velvia is less sensitive to yellow than the meter, I knew it would render some detail.

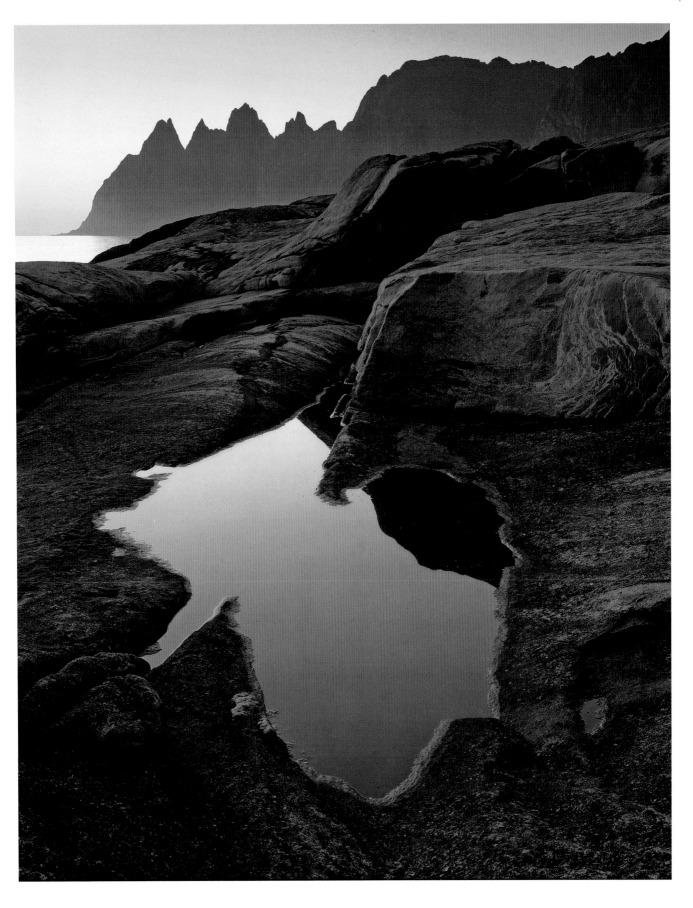

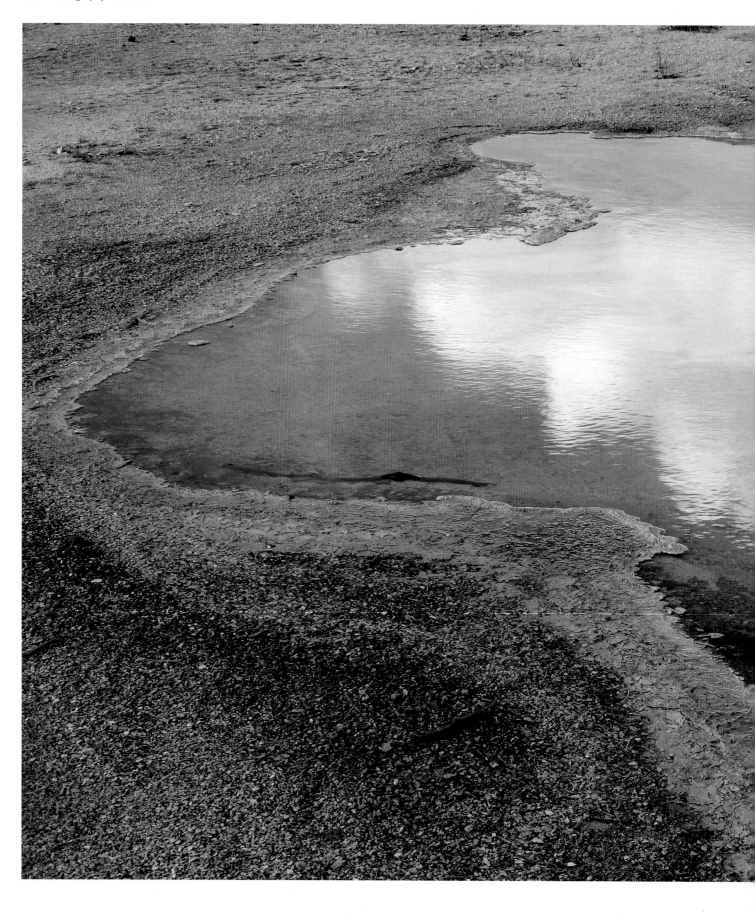

Biscuit Basin, Yellowstone National Park, USA | David Ward

I would have liked to take this picture on my 5 x 4 in camera, but the light was very fleeting. I could see the reflections wouldn't be there for long, so had to use a digital compact camera. I like the spatial ambiguity and the strangeness of the reflections – which are due to the water being in a hot spring.

trip would be an excellent tally for me. Other people might end up with the same number but have shot hundreds to get there. This seems to me like a huge dissipation of effort. The key to achieving those 15 images without too much wasted energy is concentration. I think about image-making the whole time I'm away. I certainly don't treat it as a holiday. While I try to absorb some of the culture of the places I visit my main focus is making pictures – food and a bed are incidentals.

Keep an open mind

I nearly always look for landscapes that are stripped down, elemental. Coasts, mountains and deserts satisfy that need. But I rarely travel with much of a plan about the images I might make. Some photographers spend a great deal of time planning, working out when the light might be right in a particular place and suchlike. I prefer to keep myself open to possibilities. If I spend too long on research I know my pictures will be predictable, so I tend to go somewhere and simply explore until I find something or somewhere that piques my interest.

I prefer to photograph places that are anonymous, because such locations offer you the freedom to interpret them in whatever way you like. If somewhere is well photographed it's difficult to convey anything fresh. Take Watchman Overlook in Zion National Park, Utah, for example: it's an incredible location, but what does any image you take there say that hundreds of others haven't already said? For me, the most important part of taking a picture is that it's evocative. Where it is doesn't really matter, as long as the picture evokes a response.

Limitations of light

The most crucial part of travel photography is to match the composition with the light. This is where people fall down if they have a very specific goal: they reach their destination and, even if the light or weather isn't right, they shoot anyway because they've made up their mind they're going to photograph that subject. That's the wrong attitude, because the result is an image that doesn't make the best of the conditions. For me the subject is dependent on the conditions, so whatever the light I'll search for a subject that fits it. I'm much more likely to do that than find a stunning place and wait for the right light. I might end up photographing something that's just three feet across, rather than the broad vista. But if that's what works in the prevailing conditions you have to make the most of the chance.

Above all, travel photography is about being receptive to the unusual and the unexpected. By looking at too many pictures of a location before you go there, you risk restricting your possibilities because you develop preconceived ideas about the place. In fact some photographers visit a place with the sole purpose of recreating a very specific image. To me that will always seem a redundant exercise. The landscape is my raw material and I have to try to push others' images to the back of my mind, and approach every place as freshly as I can. If I happen to be north of the Arctic Circle during summer, that might mean becoming nocturnal , because the best light is between 10pm and 3am. Or if I'm in the Namibian desert, it might mean heading for the shadows, because it's more interesting – not to mention more straightforward – to photograph in bounced light than it is in direct light. Whatever technical approach I employ the most important thing is to see the world through childlike eyes, to revel in its wonder and try to capture that in as fresh a way as possible. ■

Engineer's house, Kolmanskop, Namibia | David Ward

The top floor of this ruined mine engineer's house is missing and only the laths remain. These let through the light, which creates the eerie stripes. The way the doorways sit within each other in the patterns has something of the Magritte about it.

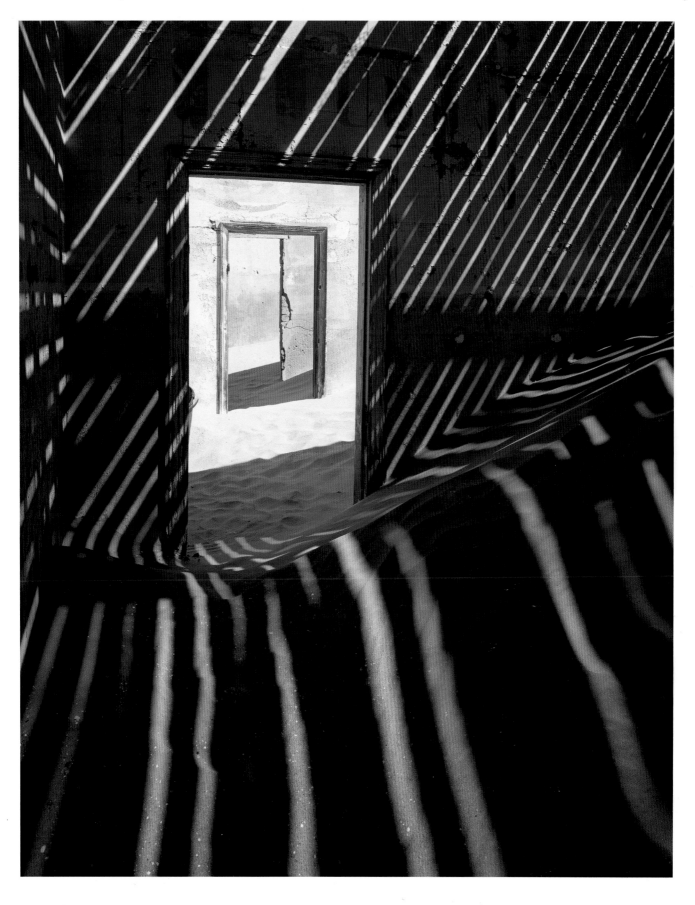

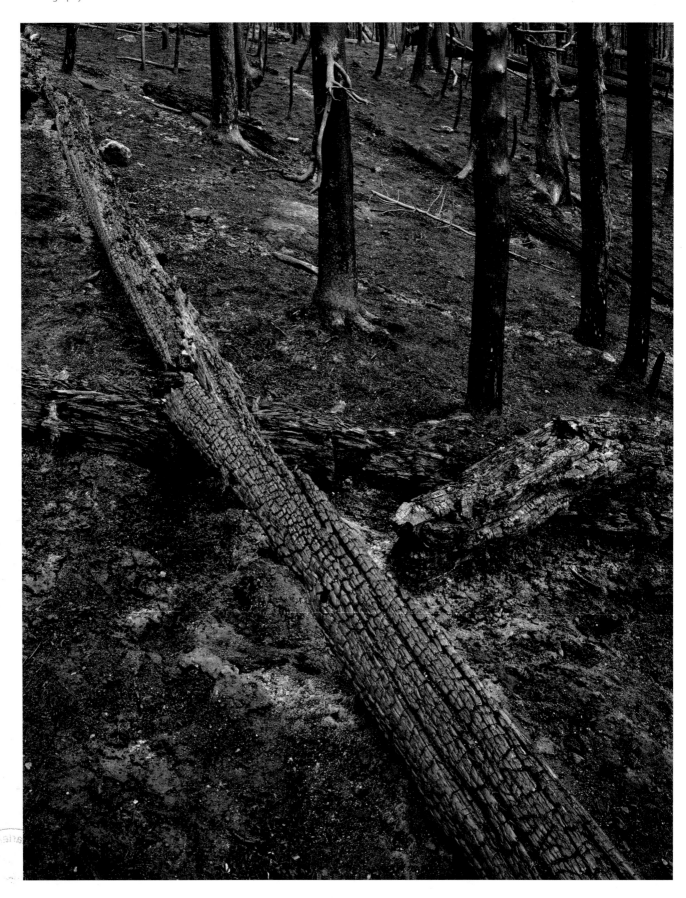

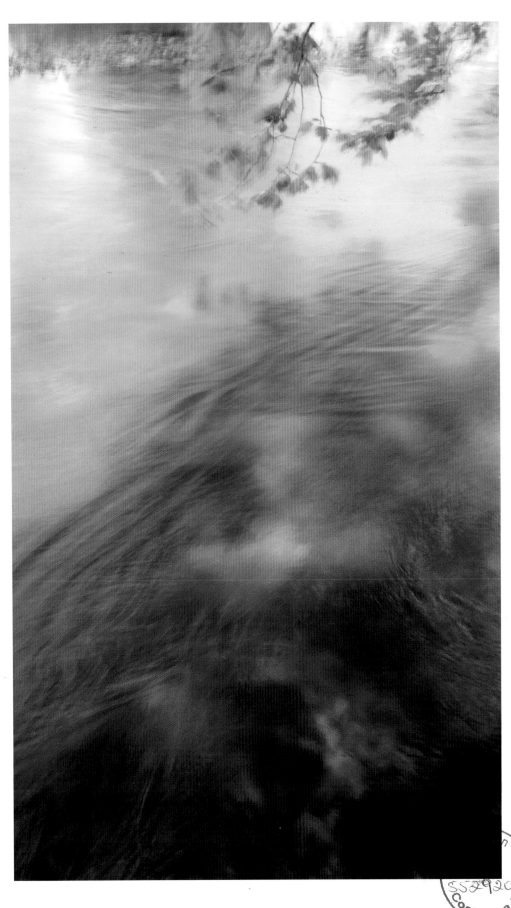

LEFT: **Burnt forest, near West Thumb, Yellowstone National Park, USA** | David Ward

I think this forest fire had occurred only a couple of months before I was there, because the ash was still very fresh. While this picture is a challenge because it's a case of black on black, there are some little flecks of colour where the burnt bark has peeled back. Some people have even said it looks like it's still on fire.

RIGHT: **Fontaine de Vaucluse, Provence, France** | David Ward

The exposure for this handheld image is 1.5 seconds, so not a single part of it is sharp, but that was my intention. As a result, it's just about the play of light and colour, and the overriding greens.

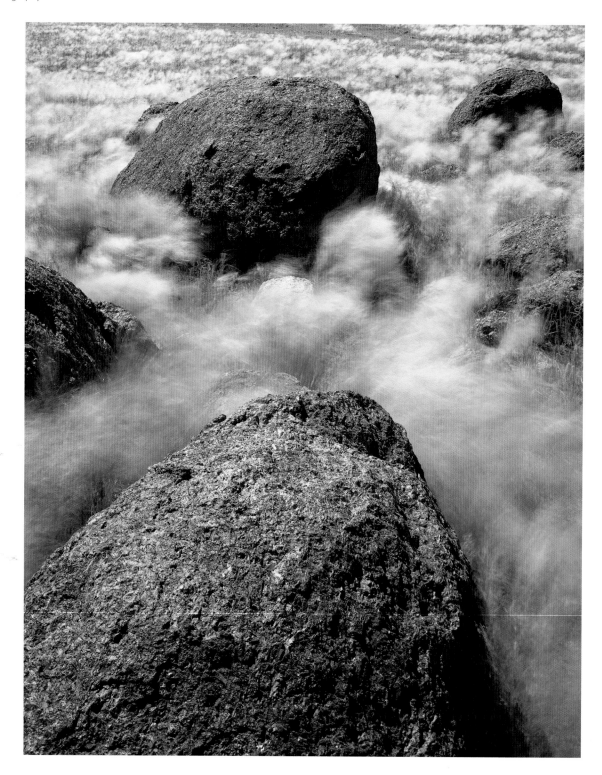

Hard Rock Café, Wolwedans, Namibia | David Ward

At 665 square miles (1,722 square kilometres), Woldewans is the largest private nature reserve in Africa. It features this grass, known as tall bushman grass. As it was the middle of the day, the light was extremely harsh. There was also a very strong wind, so even a ½-second exposure resulted in a great deal of movement. It was important to retain some sense of form, which would have been lost with a longer exposure.

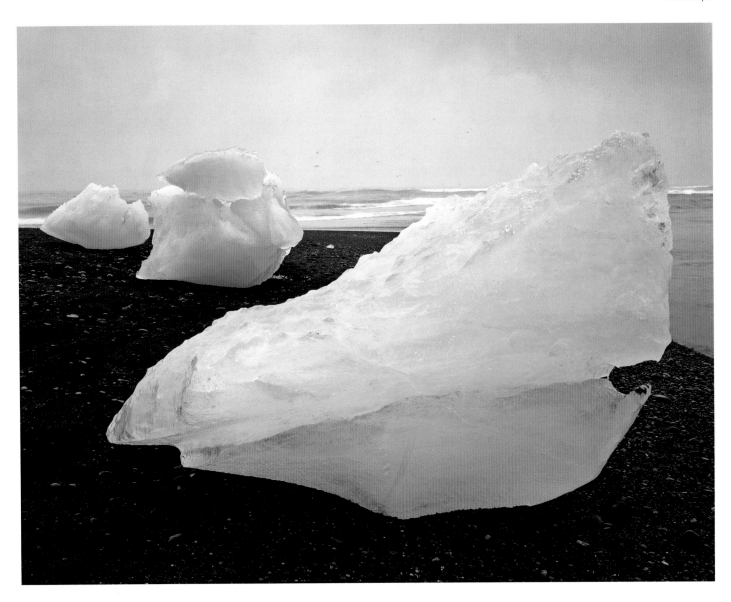

Case Study | David Ward
Three of a kind, Jökulsárlón, Iceland ..

Up until 1960 a glacier ran all the way to the sea on this part of Iceland's south coast. As it retreated, it left behind a lagoon and some huge icebergs, which float into the sea and then wash back onto the shore if conditions are right. And they are as blue as they appear in this photograph. The dull conditions and tone of the sky were perfect for the subject which, as I discovered the following day, didn't work nearly as well in bright sunlight. The composition was like solving a three-dimensional puzzle, as I had to position the camera so that the three icebergs 'nested' together. The front and middle bergs were about the same size, so I had to

place the camera in such a way as to achieve a sense of recession. This was enhanced by deploying a little rear tilt on my 5 x 4 in camera, which alters the perspective, making the object nearest the camera appear larger than it actually is. It was also important that the horizon was in the right place. It needed to bisect the bergs enough to look deliberate, but had I gone too low there wouldn't have been enough of the sea in the composition. Simplicity is always one of my watchwords, and this is a case in point. I wanted to present the icebergs as clearly and straightforwardly as possible, and simply show how amazing they are.

LANDSCAPE GALLERY

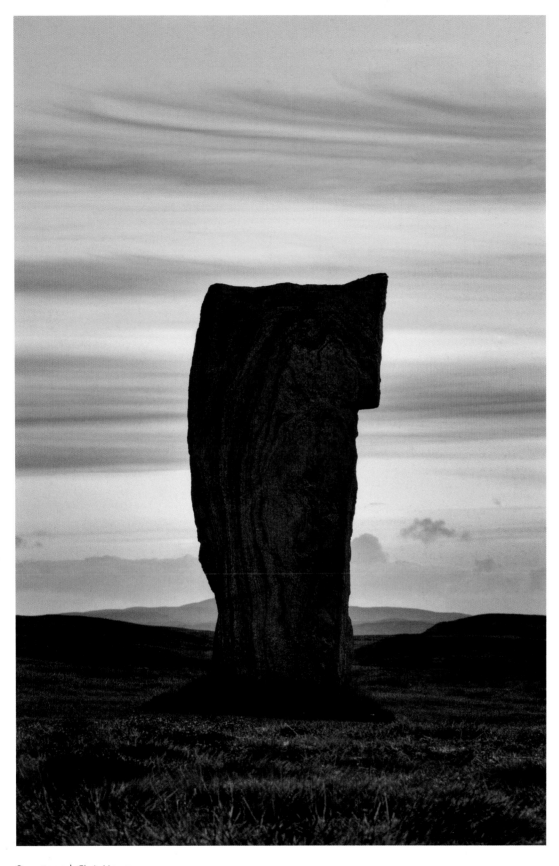

One stone | Chris Howe

Be open to possibilities

If something catches your eye, always stop to explore it. You might miss out on your original goal but you'll usually end up with something more interesting.

p25 **One stone**
Callanish, Isle of Lewis, Scotland

Chris Howe

p27 **Sand and mud patterns**
Sossusvlei, Namib Desert, Namibia

Anna Booth

p25

p27

Inspiration: Following a midday visit to the stones, I returned before sunset, hoping for some colour in the sky, at the end of a sunny day. After photographing groups of stones earlier, and trying to keep other visitors out of shot, I decided to home in on an individual piece of Lewisian gneiss. The sky had a few wisps of cloud, and a little colour.

The situation: Unlike Stonehenge, the Callanish stones are freely accessible, so you can stand your tripod where you like. I moved to a position where the stone was against the best cloud backdrop. The sky was much brighter than the stone and, not wanting a silhouette, I decided to take three bracketed exposures, to merge later. As I wanted the distant sky as well as the closer stone to be sharp, a small aperture was essential.

Camerawork: Canon EOS-1Ds Mk III with Canon 70–200mm lens at 200mm, ISO 200, ¼ sec, one second and four seconds at f/25, tripod.

Post capture: The three RAW files were merged in Photomatix, then brought into Lightroom where the brush was used to lighten the stone further.; Clarity was added to bring out the clouds, along with Vibrance (which typically boosts the blue in this type of image). Negative aqua shift reduced the green of the grass, allowing concentration on the sky colours; and finally I added a positive orange shift.

On reflection: *If I were to work on this image again, I would probably make it less blue – that is, I'd do away with the Vibrance adjustment. I have since cropped a little off the top as I feel that 2:3 ratio portrait images are a little too long. I am sure that returning at dawn or for another sunset would reveal different images again.*

Inspiration: This one of those rare moments where the image just clicked in my brain with no effort at all. Having said that, I had been wandering around in the sand dunes for a number of days, so I was very tuned in to their beauty. On this particular day I had already photographed several other equally attractive specimens and thought my picture-taking was over for the day, but then this composition leapt out at me. It's hard to describe what attracted me, other than that it achieved a balance which I found pleasing.

The situation: The sun was setting and I was working on a large-format camera – not the most auspicious of conditions. However, I set up my Ebony in record-breaking time. It's the fastest photo I've ever taken!

Camerawork: Ebony 45SU, Velvia 50 Quickload.

On reflection: *There are aspects of the image that are not perfect, but they tell a story of the day and the experience; when I look at this image I recall the joy I felt at the time.*

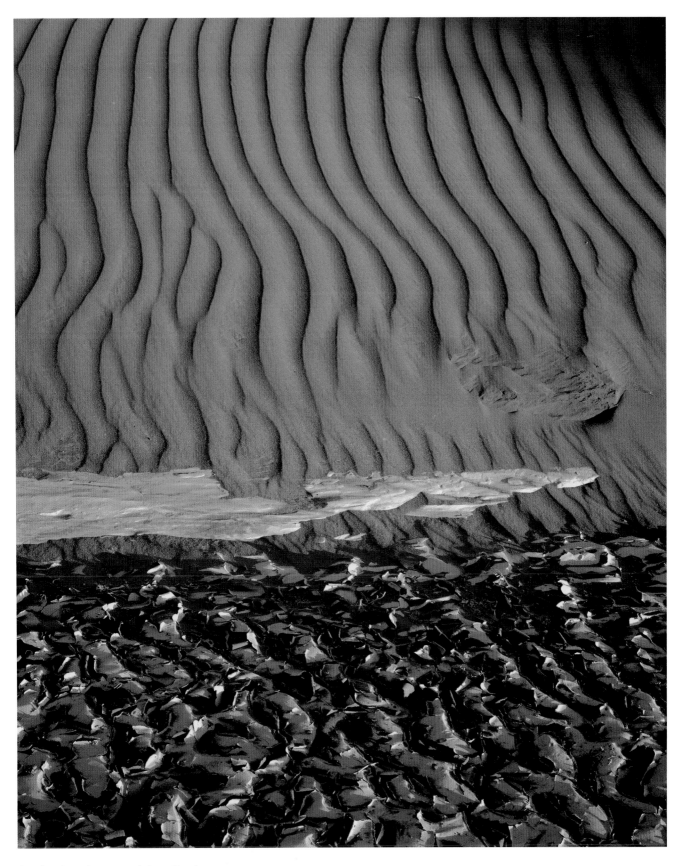

Sand and mud patterns | Anna Booth

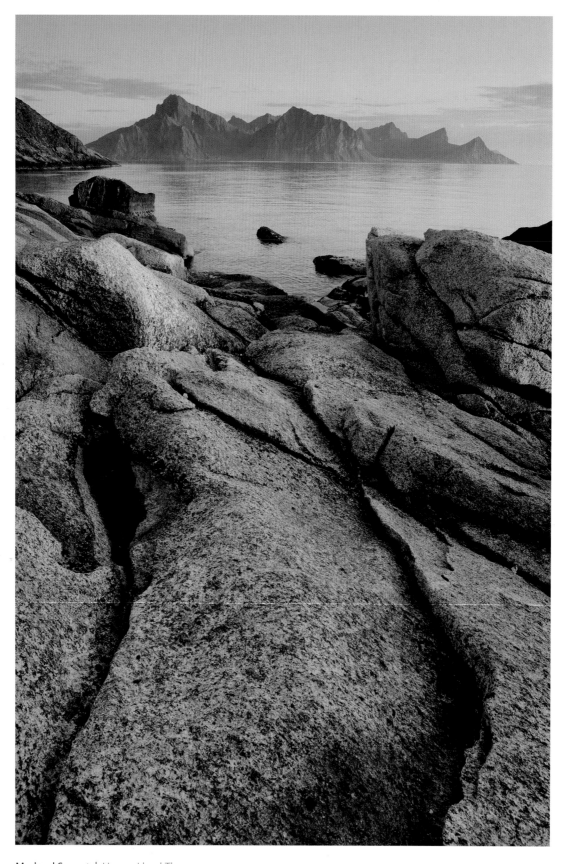

Myrland Sunset | Harvey Lloyd-Thomas

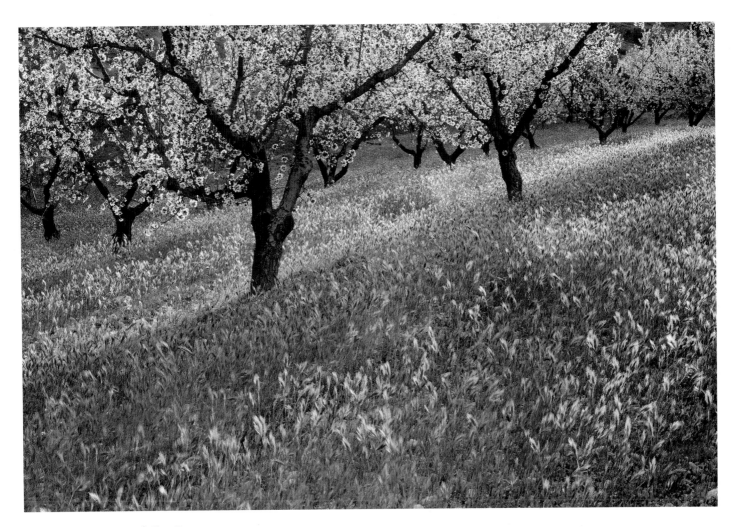

Almond grove in spring | Chris Howe

You don't always have to make a photograph

It's also important to recognise those times when it isn't worth your while taking a picture at all. That is rarely the location's fault and is usually down to the photographer. You might go somewhere and not make any photographs, but return a few months later and see images everywhere. The location hasn't changed in the interim, but the photographer has.

Rock detail | Janneke Kroes

Even well-known locations can produce individual images
Although you might be visiting places that have been photographed countless times before, that's no excuse for not making your pictures your own. If you work hard to put your own stamp on an image, the result will say more about you and the message you are conveying than it does about the location.

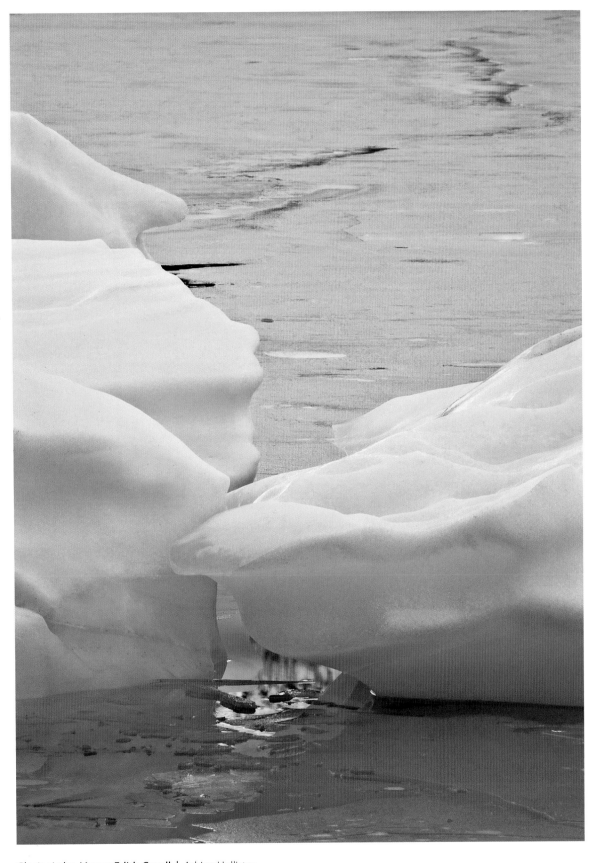

Glacier Lake, Mount Edith Cavell | Adrian Hollister

Challenge yourself

Try to work outside of your comfort zone, wherever you are. Photograph in conditions you wouldn't normally consider as being right for photography.

p28 Myrland Sunset
Lofoten Islands, Nordland, Norway

Harvey Lloyd-Thomas

p29 Almond grove in spring
Near Alhama de Granada, Andalucia, Spain

Chris Howe

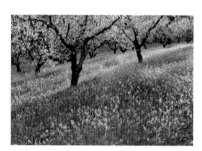

p28

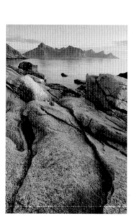

p29

Inspiration: I rarely use a tripod and my style tends towards more abstract macro landscapes, concentrating on and isolating parts of a scene, often with a telephoto lens. This, however, was an attempt to take a traditional wideangle shot which was recognisably of a place. I had visited the beach at Utakleiv on a previous evening and on this return visit I walked further around the headland looking for new images. I wasn't disappointed when the view opened up across to Myrland, the next island in the chain.
The situation: I had to work reasonably fast to set up my camera, as the warm light falling on the foreground rocks was starting to disappear. I spent the rest of the evening shooting water swirling around a rock just off the shore, with longer and longer exposures as the light faded.
Camerawork: Nikon D700 with AF-S Zoom-Nikkor 17–35mm f/2.8D IF-ED lens at 19mm, ISO 200, 1/10 sec at f/16, 0.6 ND hard grad, tripod.

On reflection: *I also tried a landscape composition, but the portrait orientation definitely worked better. I have thought about cropping the bottom in order to create a 5:4 format, but if I did I'd lose the leading curve of the rock in the bottom right of the frame.*

Inspiration: We travelled out from Granada in spring, hoping to find some almond blossom still on the trees. Blossom in the lower orchards had fallen, but as we rose higher we found our goal, but only just in time; two orchards were in bloom on either side of the mountain road. At first I shot the other orchard, as it was being directly lit, but then I turned my attention to the second, climbing up into it and finding myself *contre-jour*. The sun was sinking low but this highlighted the grasses rather than the initial target of blossom. The light was marvellous so it was just a case of making the best use of it.
The situation: Looking uphill into the low sun to the right was a problem and I had to avoid lens flare. The rim of my hat is always useful as a shade. I was down in the next field, some three feet lower, hence it was fairly easy to get low down, although the tripod legs all ended up at different lengths. Depth of field is an issue with a longer zoom lens, so I went for a small aperture, but not the smallest, as I was concerned the result might appear soft.
Camerawork: Canon EOS-1Ds Mk II with Canon 70–200mm lens at 70mm, ISO 200, ¼ sec at f/25, tripod.
Post capture: Processed from RAW in Photoshop CS3, with local contrast adjustments, single colour saturation boosts and USM 20–200 to add punch.

On reflection: *This is almost a duotone image – pink and orange, with the stark, silhouetted tree trunks to add form. It's one of those all-too-rare images that exceeded my expectations and it brings back the feeling of being there.*

Don't ignore your standard lens

People often think that the perspective of a standard lens is boring, but the 'quiet' images associated with the middle focal lengths can often stay in the mind longer.

p30 Rock detail
Glen Orchy, Argyll and Bute, Scotland

Janneke Kroes

p31 Glacier Lake, Mount Edith Cavell
Jasper National Park, Canadian Rockies, Canada

Adrian Hollister

p30

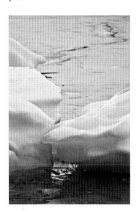

p31

Inspiration: This image was made on the banks of the River Orchy. In this particular stretch you can clearly see the many different layers of rock, and I couldn't help wondering how long it must have taken to shape this part of the world. I was especially attracted to the curve and the way the layers seem to be so compacted that part of the rock appears to be spilling out like cream from a cake.

The situation: There was a small ledge on which I could sit quite comfortably and place my tripod. I first concentrated on the part that had originally attracted my eye. After trying out a few portrait-shaped compositions, I decided in the end to go for a landscape image that also included some of the submerged rocks to the right, as I found the colour contrast intriguing.

Camerawork: Nikon D70 with AF-S Nikkor 18–70mm lens, ISO 200, 0.6 sec at f/11, tripod.

Post capture: I worked on the image in Lightroom, increasing the contrast and enhancing the colour balance to bring out the contrast between the blue rocks on the left and the yellow water on the right.

On reflection: *Originally I was attracted to the different layers of rock on the left and I mainly focused on those. I think the shapes on the right are interesting too, and I wouldn't mind going back and trying some different compositions with those. Although I guess the water level would have some influence on what is possible!*

Inspiration: The scenery around Glacier Lake, in the Canadian Rockies, was both unexpected (glaciers in the warmth of an autumn afternoon) and quite enchanting. I spotted two of my fellow photographers working on images on the opposite side of the lake from me, so I went to see what had attracted their attention.

The situation: They had noticed that the sun, which was behind them, was reflecting light off the sandstone rocks on the edge of the lake, creating a beautiful contrast of golden yellow light against the blue colour of the glaciers. I worked for some time to find an interesting composition, and had to stretch my lens to the maximum focal length and aperture to make this one work.

Camerawork: Canon EOS 5D with Canon 70–300mm f/4.5-5.6 DO lens, one second at f/38, polarising filter.

On reflection: *I was pleased with the image and composition, but in order to maximise the quality of the final image I should have used a faster speed and increased the aperture from f/38.*

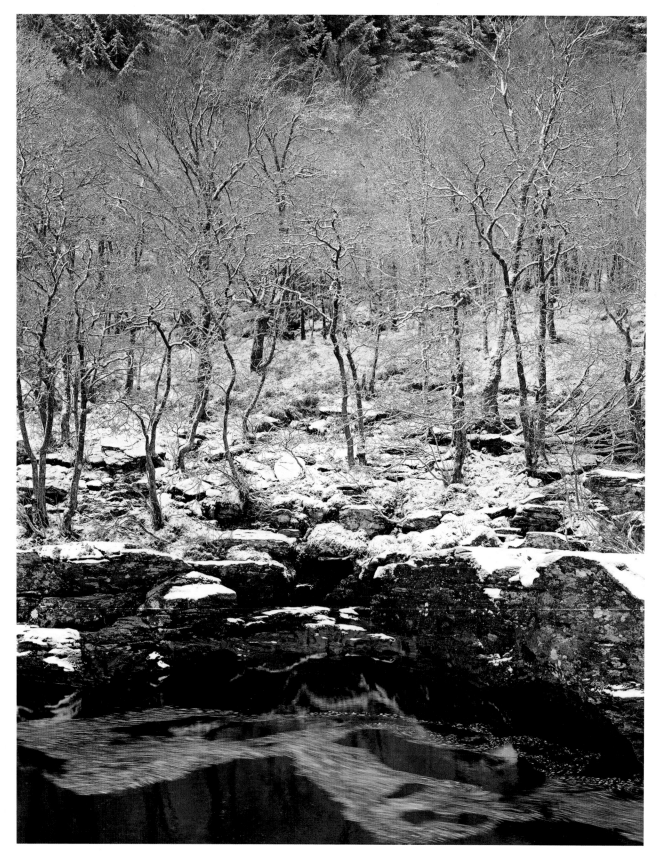

River Orchy Fantasy | Jon Martin

Doing a recce

If you have the time, scouting for locations can be as enjoyable as the photography itself. Exploring a region for picture-taking opportunities is a bit like solving a puzzle.

p34 River Orchy Fantasy
Glencoe, Scotland

Jon Martin

Top Tips

p34

Inspiration: I spent some time thinking about the 'seeing' of images, which helped give me confidence in my own vision. I was struck by the quiet, almost understated beauty of the location and wanted to capture the essence of it on film.
The situation: The light was low and had a strong blue cast. Sunset had long since passed and the residual light was filtered by a layer of snow clouds. The light was also being reflected by the snow and ice, which was everywhere. It was also snowing at the time which means the image is a little soft, particularly in the more distant parts of the frame. But this quality, along with the serenity of the scene, appealed to me enormously.
Camerawork: Horseman 45FA with Schneider 150mm lens, six seconds at f/22.
Post capture: Only a small amount of work was carried out on the drum-scanned image. I used a little bit of Curve adjustment to increase contrast very slightly and applied a small amount of burning in to the blue water at the bottom of the frame. In addition, colour correction was done in order to better match the original transparency.

On reflection: *For me, this image captures the mood and feeling of the location at that moment. The wealth of information in the mid-ground trees and the sparkle of the reflected light accentuates the feeling. I wish, on reflection, I had taken a step or two backwards to include slightly more of the background trees and also to allow some space between the slowly drifting bubbles and the bottom of the frame.*

1. Take your time; don't rush into making the 'classic view', but look at the alternatives and try to find your own interpretation of well-known places by using a range of focal lengths and looking for different angles of view. You may need to visit a place a few times in order to find these alternatives.

2. Do some research into the best time of day to make an image; you can get apps for the iPhone or PC that will tell you the position and time of sunrise and sunset. Try to work out what would be the best kind of light for your subject; would directional or even illumination be preferable?

3. Work out what you want to say about the place in your image. Do you want to show how cold it is? How hot? How arid? Pick elements in the landscape that emphasise these attributes and put them in the foreground of your image.

4. Don't just think of making an image of the vista – look at the details at your feet. They may carry even more powerful messages.

5. Use graduated filters to control the contrast in the scene and render the sky and foreground as you perceive them. Landscape images should seem interchangeable with our vision and not be obviously filtered. **DW**

PHIL MALPAS

A flexible approach

One of the key differences between photographing when travelling and photographing at home is that when you are away you need to be able to adapt – and sometimes react – to an unfamiliar environment. At home you can go out whenever the light is good; when travelling you have to work with whatever conditions you find, in a limited time, and be ready to revise your aims and ambitions.

Before you go

Any research you can do before you leave is always useful, but there are two main elements you should concentrate on: light direction and times of sunrise and sunset. It is possible to work out what the direction of light will be at the time you visit a location by using one of the many sunrise and sunset calculators available on the internet – and if you aren't on the equator, this alters depending on the season. It is worth making the effort in particular to establish the direction of the sun at both sunrise and sunset, which will then give you a fair idea of its bearing during the rest of the day.

When carrying out an internet search for sunrise and sunset calculators, use the word 'photography' in your search to find the most relevant ones. You can even get an application to run on some mobile phones that will assist you in making your calculations. When working at latitudes similar to my home in the UK, I work by the rule of thumb that, in mid-winter, the sun rises in the southeast and sets in the southwest, while in mid-summer it rises in the northeast and sets in the northwest. By using this information, together with maps of my chosen destination, I stand less chance of a wasted journey by turning up at the wrong time of day. Even when I'm not travelling far, I study as much local information as I can, in order to get the most out of a location.

In search of originality

In this age of cheap flights and increasing travel options, one of the greatest issues surrounding travel photography is that the world is a much smaller place. It is increasingly difficult to make original photographs in popular locations. Naturally, it can be tempting to recreate something similar to pictures by another photographer who you might admire. Take an iconic location such as the mountain of Buchaille Etive Mòr in the Scottish Highlands. Just because it has been photographed thousands of times doesn't mean you shouldn't make your own interpretation of it. After all, weather conditions are never the same twice, and although there's only one 'Buckle', there are infinite foregrounds available. You make it your own, not by setting up in someone else's tripod holes, but by choosing what to include in your composition other than the mountain itself.

With landscape photography, the best results come from shooting in conditions that match the scene. For example, if you don't have dramatic, spectacular light, there's little point in attempting to photograph a grand vista. If the light is poor, go closer instead. Look for detail shots, because not only are these often suited to less than ideal conditions, but they can also speak as eloquently as the grand vista. Moreover, →

The why and where of a picture

The location of a successful travel picture is almost irrelevant. The best images stand out not for where they were taken, but what they say about a place. Having said that, however, it's important to caption your images, as without them the viewer can feel rather cut adrift.

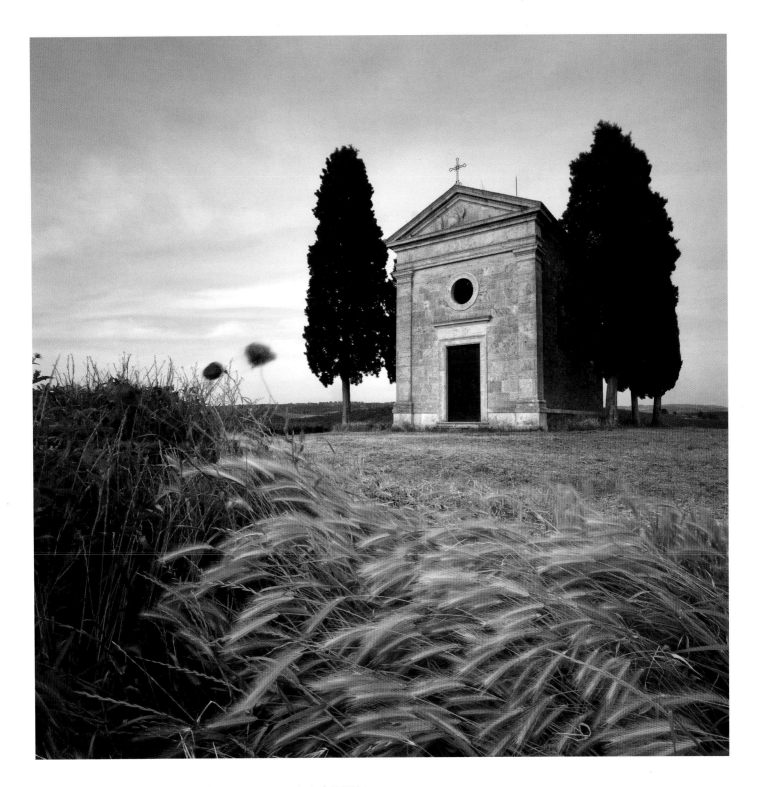

La Vitaletta, Val D'Orcia, Tuscany, Italy | Phil Malpas

La Vitaletta is normally photographed from the main road between San Quirico d'Orcia and Pienza.
On this occasion I tried to get a different composition of the chapel by going closer. I used a number
of ND filters to obtain a long exposure, which captured movement in the foreground crop.

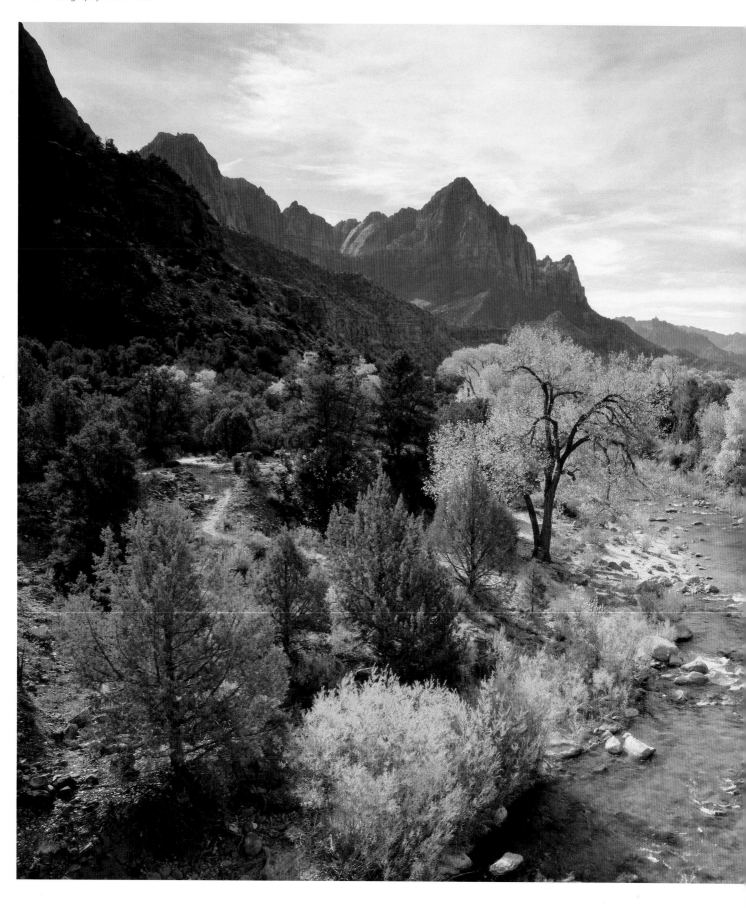

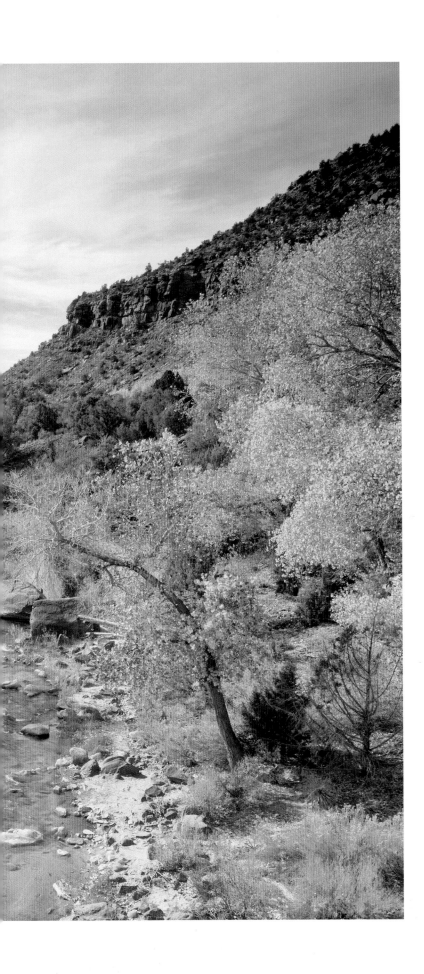

The Watchman, Zion National Park, USA | Phil Malpas

This is a very popular spot at sunset, when the last light hits the mountain known as 'The Watchman' from the right. I elected to photograph the view in the late morning when all the fantastic foliage was heavily backlit. Careful ND graduation was needed to capture full detail in the foreground without clipping the highlights in the sky.

they are unique, as the likelihood of any photographer ever composing an identical image is slim indeed. If the conditions don't suit the shot you originally had in mind, it's important to think laterally and use your imagination, rather than feel thwarted in your aims. Flexibility is essential.

What to take

Thinking about what you want to achieve on your travels can also help with your packing. Depending on the trip, I take either a DSLR kit if it's a commissioned shoot, or my 5 x 4 in if I'm making purely personal images. Only rarely will I take both because, when I travel by plane, I never put my camera bag in the hold, so I'm limited to a degree by what I can take on board as hand luggage. The camera bodies stay in my pack, and the lenses go in my coat pockets!

If weight really is an issue, I take just one mid-range lens and work with that. While it might appear limiting, knowing one lens inside out and understanding how it 'sees' can be a useful creative exercise. Yes, you might have to forego, say, a picture that cries out for the wideangle treatment, but there's every chance you'll challenge yourself to explore your surroundings a little more deeply, and look for images you may not otherwise spot if you're in possession of a complete armoury of lenses. Sometimes you have to decide that you can't take everything, so by knowing in advance what it is you are likely to want to photograph, you can pack only what you are certain you will need.

Avoid the obvious

One of the dangers of over-researching a travel destination is that you can find yourself photographing the obvious. I always advise people to get these obvious images out of the way quickly, as this then frees them up to be more imaginative throughout the remainder of the trip. Many people aren't fortunate enough – because of time constraints and other restrictions – to be able to take photographs as often as they might wish to. If your only opportunity to take pictures arises on holidays and trips, it can take a little while to 'warm up', creatively speaking. As a result your first picture is unlikely to be your best, so just shoot that frame and move on. Subsequent images, taken once you have got into the swing of things and ignited your creativity, are far more likely to be the ones that end up in your portfolio.

As much as travel photography is a response to the stimulus of unfamiliar places, it always pays to give yourself some direction. On a recent trip I decided I would concentrate solely on shooting square-format black-and-white images on my digital camera – a complete change from my normal style. By the end of the week I was seeing square, monochrome compositions everywhere. While I might have missed a number of potential images that could have been made in colour, or with my 5 x 4 in camera, having a target of 50 successful images helped me to channel my creativity and to see my surroundings in a slightly different way from usual.

For me, the crux of travel photography is that in order to get the best out of a location, I really have to have enjoyed it. I have spent five hours in Antelope Canyon, Arizona, that felt like five minutes, and been overcome by the colours of New England in the fall and by the spring flowers in the Pyrenees. Essentially what I love about photography is that it has taken me to places I would never otherwise have seen. Photography, for me, is the reason to travel, rather than something I do when travelling. ∎

Compacts can be just as versatile as SLRs

Digital compact cameras are great fun. If you've been struggling with your photography, leave your 'serious' kit behind and take a compact out with you instead. It can be very liberating and might provide just the creative boost you need. It also works as a 'notebook' of ideas for photographs which can be followed up when you return with your full kit.

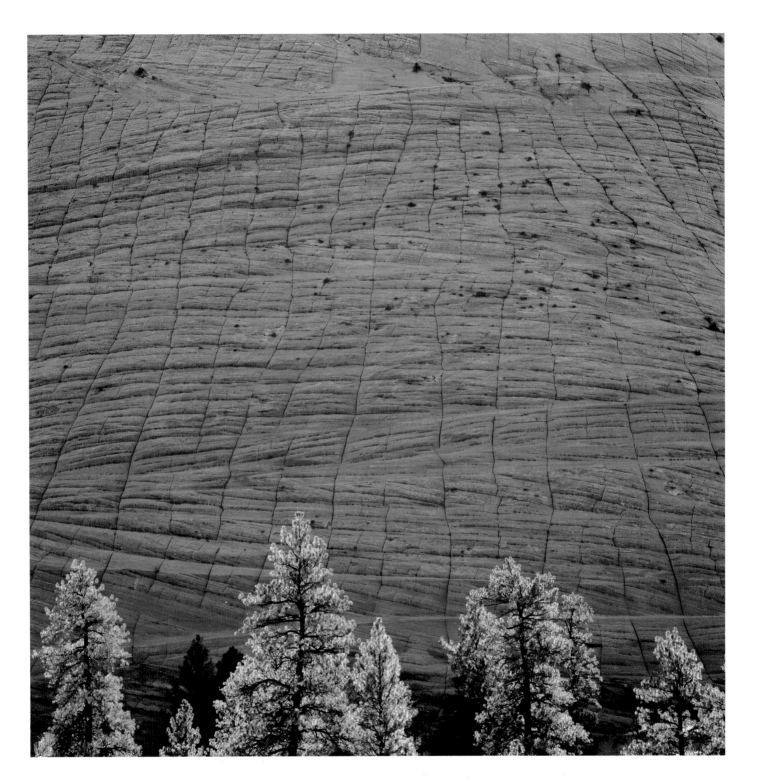

Checkerboard Mesa, Zion National Park, USA | Phil Malpas

The face of the Mesa was in shade under a deep blue sky. By carefully choosing my white balance settings, I was able to capture this spectacular blue reflection in the pale rock. The sun was clipping the Mesa at the top right, adding a distracting highlight, so I cropped to a square to remove it.

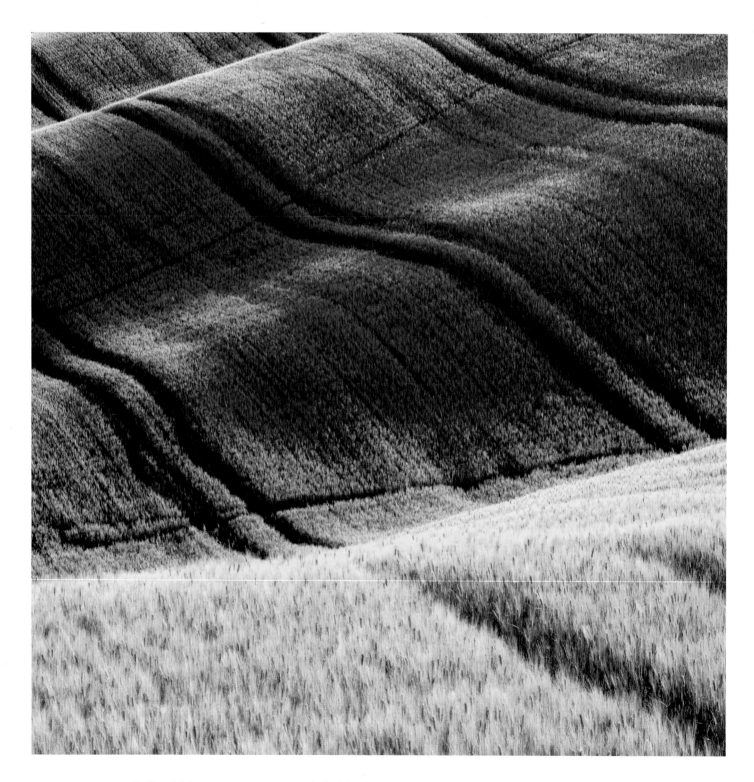

Rolling fields near Pienza, Tuscany, Italy | Phil Malpas

In the late afternoon these fields are skimmed with light as the sun reaches the horizon. The key here was to exclude anything that would complicate the composition. I found that by cropping to a square I could arrange the lines in the crops to fit neatly into the corners of the frame.

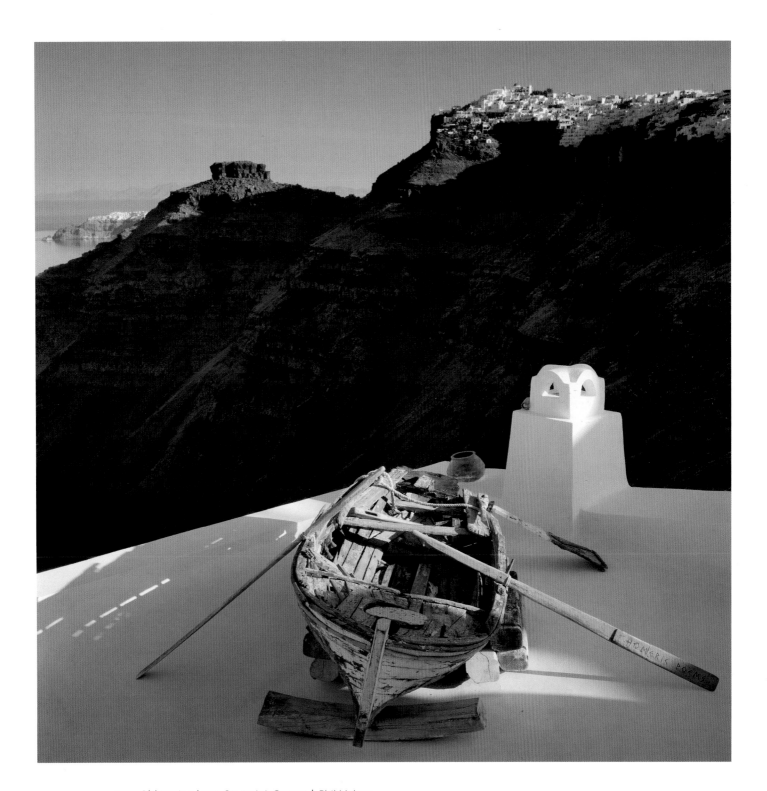

Old rowing boat, Santorini, Greece | Phil Malpas

The exposure here was complex in that there were bright highlights at both top and bottom of the frame. I utilised ND graduated filters to ensure that detail was retained in the dark volcanic cliffs. The pool of light beneath the boat only lasted for a few minutes so I had to work quickly.

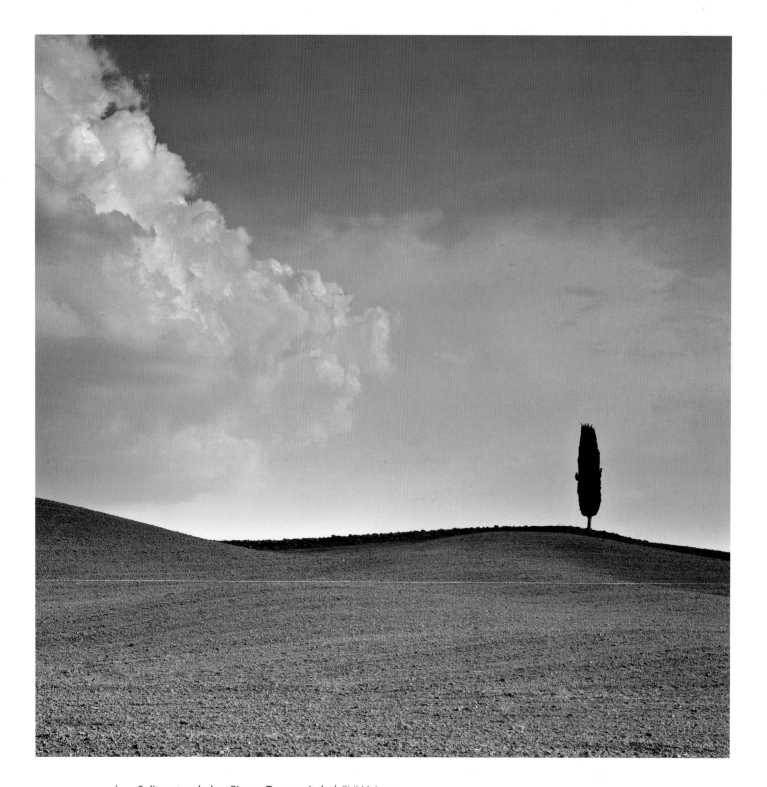

Solitary tree below Pienza, Tuscany, Italy | Phil Malpas

I spotted this fantastic cloud from some miles away and rushed to this location. I was confident it would provide a great opportunity for a very simple composition. I try hard to make images that distil the essential elements of a landscape into a photograph.

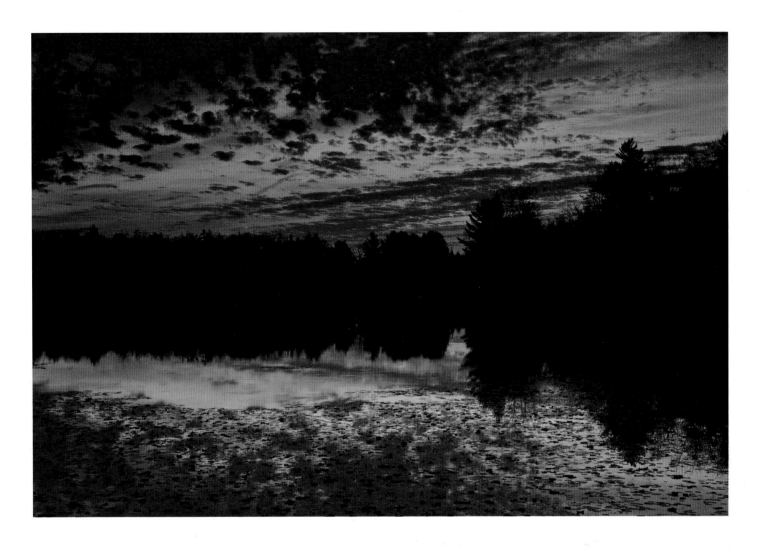

Case Study | Phil Malpas
Bliss Pond, Vermont, USA

I first visited Bliss Pond in 1997. We arrived at about midday and the light wasn't spectacular; I don't recall anyone actually taking any pictures! In 2003 I was lucky enough to be asked to lead a Light and Land tour to Vermont and after a careful study of large-scale maps, I realised that Bliss Pond would be a perfect location for a dawn shoot. Consequently, I took my clients there on the first day of the week and we had an extremely productive couple of hours. As the sun rises above the trees it often catches the mist, which swirls over the water's surface, creating exciting effects. On the second day I suggested that it might be beneficial to return to the same location for dawn, as conditions would always be different. Sure

enough we were greeted with the scene shown here, with little mist but a fantastic sky to work with. In the end we spent six dawns at Bliss Pond during that week and every one was different. I have been lucky enough now to have spent perhaps 30 dawns on the shores of Bliss Pond and I never tire of going back. This has been a key learning point for me in that if the physical structure of a location works well, then repeated return visits are always worthwhile. The lighting conditions will always be different and occasionally nature will present you with a spectacular show that you will be able to make the most of due to your familiarity with the location and the elements it contains.

CHAPTER 2 : **PEOPLE**

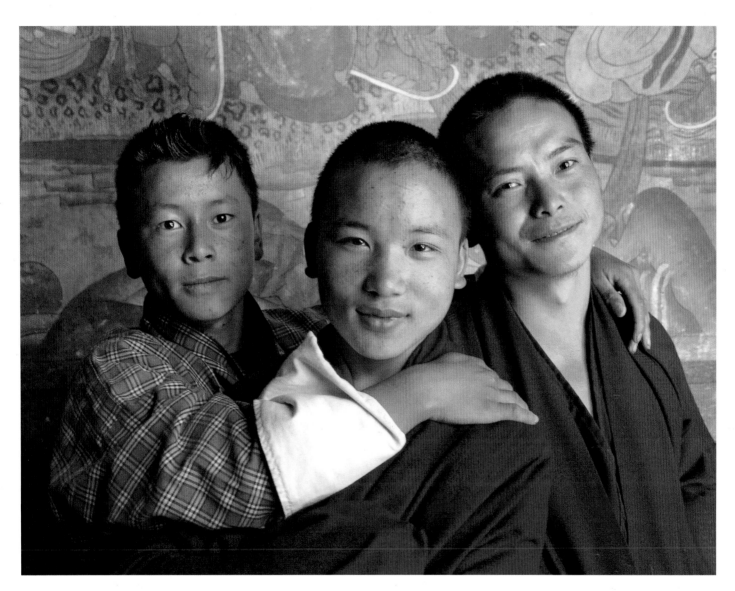

A Happy Trio | Duncan Locke
(See page 155 for technical details)

| **Plan ahead**
| *Before you leave your shores, think about what you're going to photograph, why*
| *you're going to photograph it, and what you intend to do with the resulting images.*

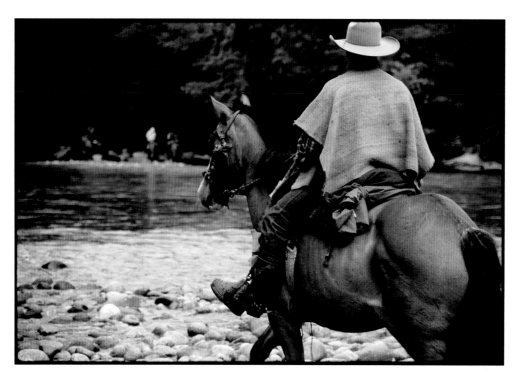

Riding up to La Junta | Lucy Heber-Percy
(See page 155 for technical details)

Introduction

If there's one thing you can't – or even shouldn't – do when travelling, it's isolate yourself from the people who make up the fabric of the area you've chosen to visit. The possibilities for better and more assured photographs are greater when you open yourself to strangers than they would be if you were to stay hiding in the corner.

Make no bones about it, though, people photography can be nerve-wracking. It's notoriously tricky to tackle successfully, and it takes a particular kind of confidence to approach a stranger in an unknown place, where the language is more than likely to be unfamiliar and the culture different from your own. For those who can overcome these difficulties, however, the rewards are plenty – and a simple 'hello', 'please' or 'thank you' in the person's language will allow you to connect with them. It is often all that's needed to transcend any apparent barriers – barriers that tend to dissolve as you gain a new insight into the place where you are a guest.

There will always be a debate about whether it is better to ask someone's permission before you take their picture, or take it without their knowledge. There is a place for both approaches, as long as each is equally respectful towards the subject. After all, many of the world's greatest photographers made their names by photographing discreetly – even covertly – and capturing a moment where the choreography of life comes together for a split second is an art in itself. **AMc**

PAUL HARRIS

The camera as passport

Just about everyone who travels nowadays carries a camera with them. But does this mean those same people are especially interested in what they are seeing beyond making a record of the world around them? We carry generic guidebooks and know we want to visit a cathedral here and a waterfall there, but I often wonder whether we ask ourselves why we're really there. To succeed at travel photography I believe we should have a passionate curiosity about, and an engagement with, the places we visit – and that the camera remains one of the best passports into peoples' lives and the places where they work and live.

To pay or not to pay?

One contentious issue surrounding people photography is whether to pay for the pictures you take. I have one simple rule: if I have stopped someone from doing whatever it was they were doing before I came along, then I will offer to pay for the pictures. Their activity – whether it's selling fruit at a market, gathering crops or pursuing their art or craft – provides them with a livelihood, so I feel it's my obligation to make a contribution. Nine times out of ten, however, my offer will be refused. The reason for this, I have always felt, is because I have taken the time to find out who they are and what they're doing rather than just firing away with a long telephoto and hoping for the best.

This vital process of engagement frequently leads to more creative and satisfying images once the introductions are over, and you have taken your more formal portraits. Your subject then tends to continue with what they were doing, giving you the opportunity to obtain more candid images. And because by that point they should be relaxed in your presence, you can take time to wait for, say, their arm to be at the correct angle, or their eyes to be looking towards the light.

Working up the confidence to approach a stranger is probably the biggest hurdle anyone has to overcome. I'm suspicious of any photographer who claims they can just walk up to someone and start taking pictures without creating some negative feelings. Learning just a few key phrases in the local language has always been part of my approach to people photography. Not only is it courteous, it is usually met with warm astonishment and a willingness to participate in your vision and understanding of their world.

Modifying light

Harsh midday or tropical light is no friend of people photography. Try moving your subject into the shade or closer to a reflective surface to utilise the bounced light. If that's not possible, don't forget your camera's pop-up flash. We usually forget it's there, but that little blip of light, when used at short distances, can give just enough illumination to flatten out harsh shadows and add a little sparkle to the eyes. The alternative is a little portable reflector, which can be just as useful.

The travel photographer's main intention should always be to convey a sense of place. You are in that place at that moment and it is your experience, but a lot of →

Rann of Kutch, Gujarat, India
Paul Harris

A women's cooperative from Hodoko engaging in traditional embroidery. The finest aari embroidery was originally carried out for royalty and wealthy families and continues to be used in dowries and fabrics for the tourist trade.

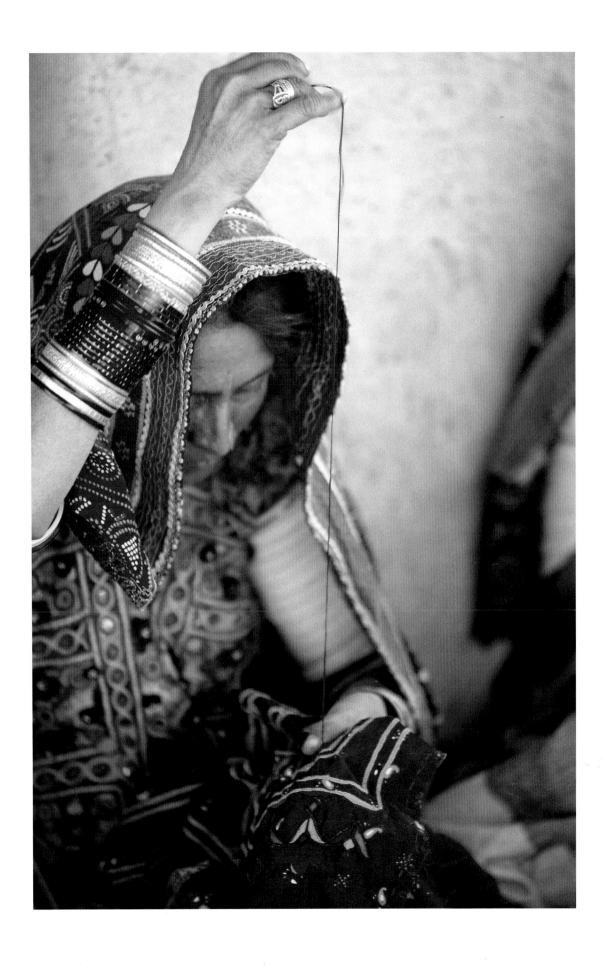

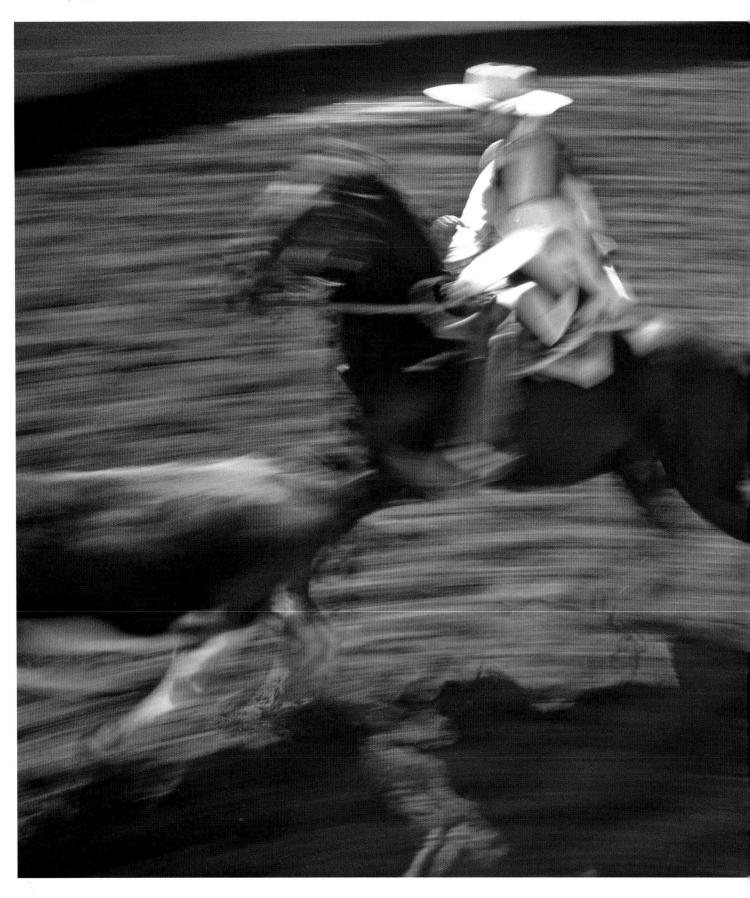

Rodeo, Cabildo, Central Chile | Paul Harris

The rodeo in Chile is a test of horse and rider, where exceptional horsemanship is the only prerequisite to winning. Rodeos in Chile are conducted in a half-moon arena, which resembles a corral, called a medialuna.

photographers become bogged down in technicalities and the process of making a good picture without considering whether it communicates that experience. In some ways, while the camera can be your gateway into places you otherwise might not go, it can also act as a barrier. Not only that, but it's the easiest thing in the world to be carried away by these new places, sights and sounds – and to lose sight of what it is you're attempting to convey. All photographers – professional or not – can be endlessly distracted by a place that's not familiar to them, but if you've devoted some time to preparation, carried out your research, and allowed yourself to spend time in a place, the pictures will present themselves. It's almost as if a little voice says, 'You deserve this'. This is nearly always the case, even though quite often I won't take my cameras out for a couple of days after I arrive. I just look. Yes, I might miss a few pictures, but that time spent familiarising yourself with a location gives you the opportunity to absorb your surroundings, and start to understand what makes it tick.

Telling someone's story

This also puts you in the position of thinking about how you're going to construct your story – because all photography is about storytelling. You only need to look at magazines such as *National Geographic* to see that images can be typecast to a degree. Firstly, you are looking for the establishing shot, the one that says, 'This is my story or theme'. It's vitally important to grab the viewer's attention, and this is the picture that does it. The story might be about just one person – a Kazakh eagle-hunter, perhaps – in which case the picture you'd want is of him and his eagle, and the landscape around them. It talks of their environment, who they are and what they do. The second image is often the 'person at work': they might be a dancer, a tradesman or a craftsman. This is invariably an easier photograph to achieve than the classic portrait, as it allows the person to be absorbed in what they're doing, and there's less chance of the subject appearing awkward or self-conscious.

Images that say something about relationships often speak volumes, too, whether it's the closeness of family and friends or the link between people and their surroundings. Less subtle is the portrait, which, more often than not, is a straight headshot with direct eye contact – a commonly used image for magazine front covers. Last and by no means least in the story-telling sequence is the detail shot, where you might choose to focus on a person's hand using a wide aperture, so that the rest of them is thrown out of focus, or make an image out of a tool they use or an aspect of their traditional dress. By following these pointers you suddenly find you've told a story in just four or five images.

Make a picture your own

Call it style or identity, or art indeed, but I believe we can all inject elements into our images which immediately convey our interest and curiosity in addition to rendering them as unique as an iris or a thumbprint. Carving our own spirit and artistry into an image rather than merely reflecting the environment we travel through is, I believe, needed more than ever, now that more people travel to more destinations and take more pictures than ever before. Regardless of the techniques we employ to tell our stories, ultimately it is the honesty and 'chutzpah' we put into our creations that will stand the test of time. We must immerse ourselves in personal stories, distil a favourite travel theme, take on the issues of travel and photography with a conscience, but above all imbue our photography with grace, style and spirit. ■

Rajasthan, India | Paul Harris

A muslim potter in the village of Kotada. The shapes made by the potter's hands are important here – as is the negative space they create. This picture speaks of concentration, craft and attention to detail, as well as being the classic 'person at work' shot that is always popular with picture editors.

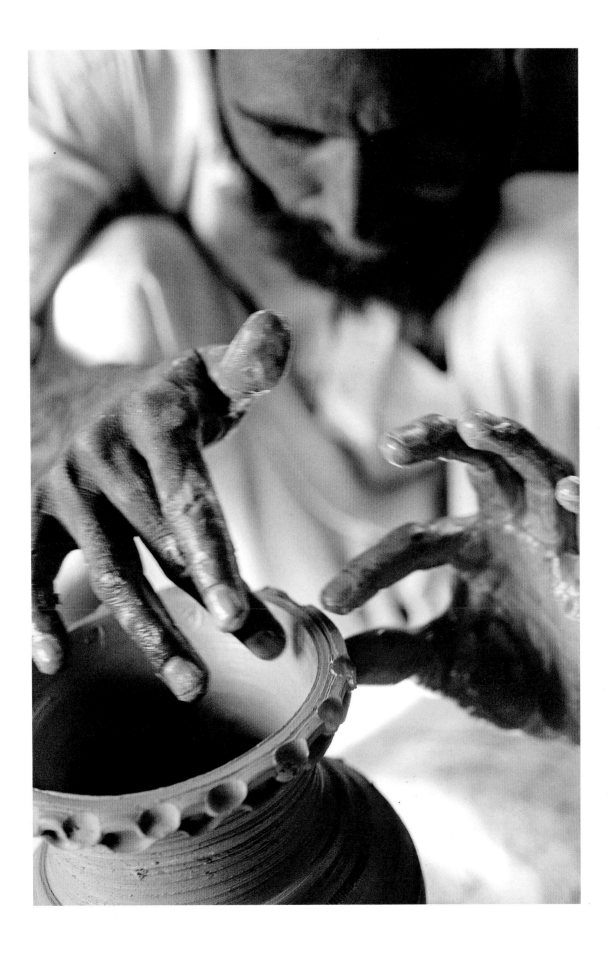

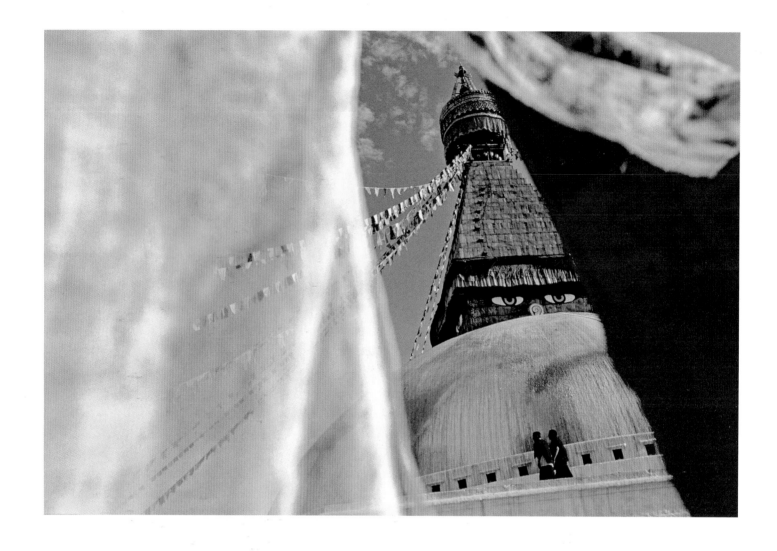

ABOVE: **Boudinath, Nepal** | Paul Harris

The ancient stupa of Boudinath is a major pilgrimage site for Buddhists, one of the most important holy places in Nepal, and also the largest Tibetan settlement outside Tibet.

RIGHT: **Elephant painting, Jaipur, Rajasthan** | Paul Harris

Painting an elephant as part of the celebrations for 'Holi', a traditional Hindu festival which takes place in the spring. Also known as the Festival of Colours, it is an exuberant celebration of friendship and renewal.

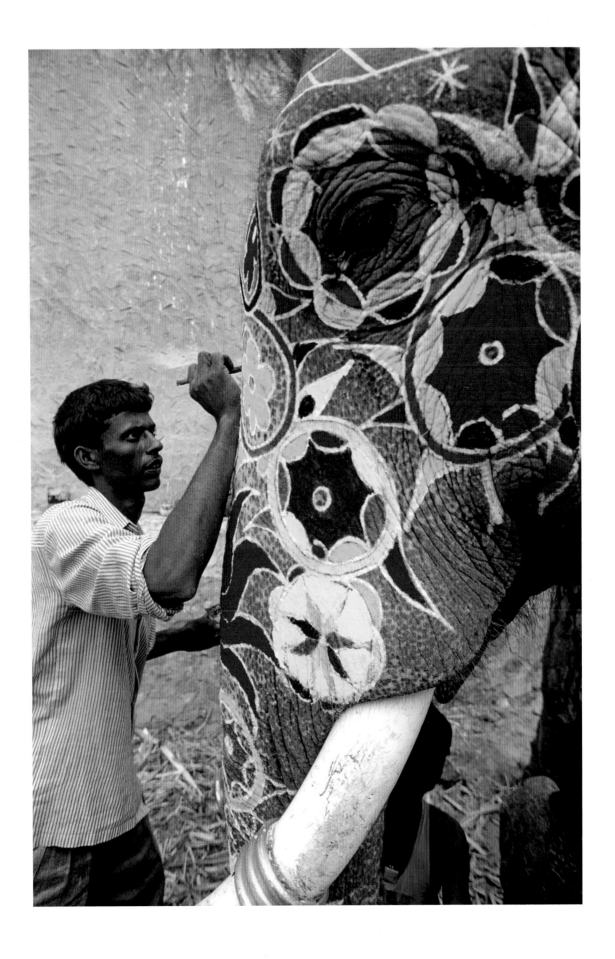

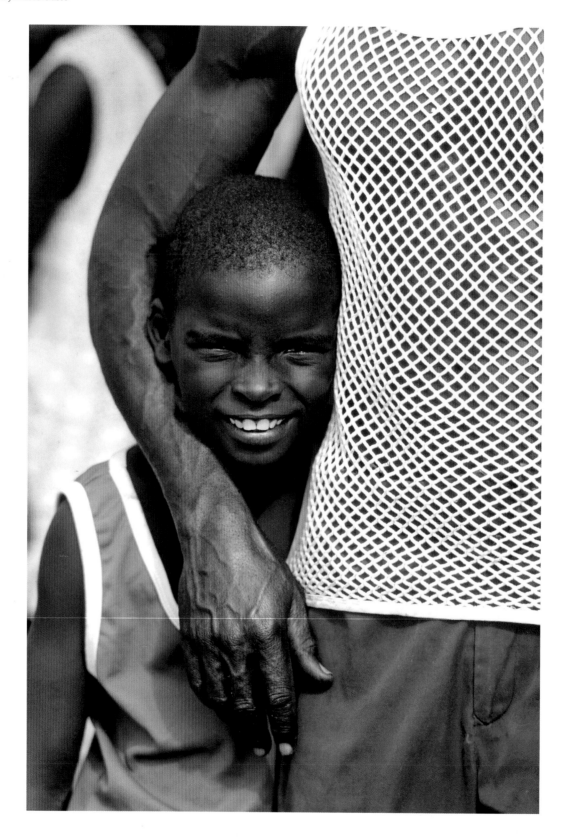

Montserrat, West Indies | Paul Harris
Young boy and his rastafarian father in a market in Plymouth, the capital city of Montserrat.

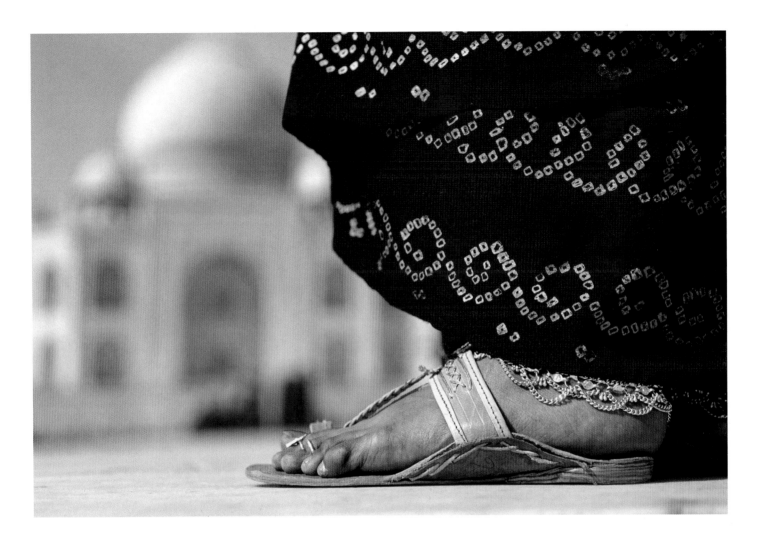

Case Study Paul Harris
The Taj Mahal, India

If I'm going on assignment – be it commissioned, speculative, or for stock – I'll make a list of possible pictures. In this example I was shooting the Taj Mahal, which is probably the most photographed building in the world. It was taken for a stock library, and even though the library had many pictures of the Taj Mahal in its files, it still wanted more.

Clients are always asking for new angles on and approaches to well-known subjects, so together we created a series of storyboards, just as if we were making a film. My editor wanted a picture that conveyed a sense of place, but where the building

didn't necessarily have to be in sharp focus, and in which it wasn't necessary to see a person's face – so this is the concept we came up with. The drawing was of a woman's foot, wearing ankle chains, with a sari wafting in the breeze, and the building we all know as the Taj Mahal out of focus in the distance. The drawing was almost exactly the same as the picture you see here. In many ways, it panders to the intelligence of the audience, because you only need a hint of both building and person. This picture also falls into the category of the classic detail shot, summing up a destination, a style tradition and sense of place.

PEOPLE GALLERY

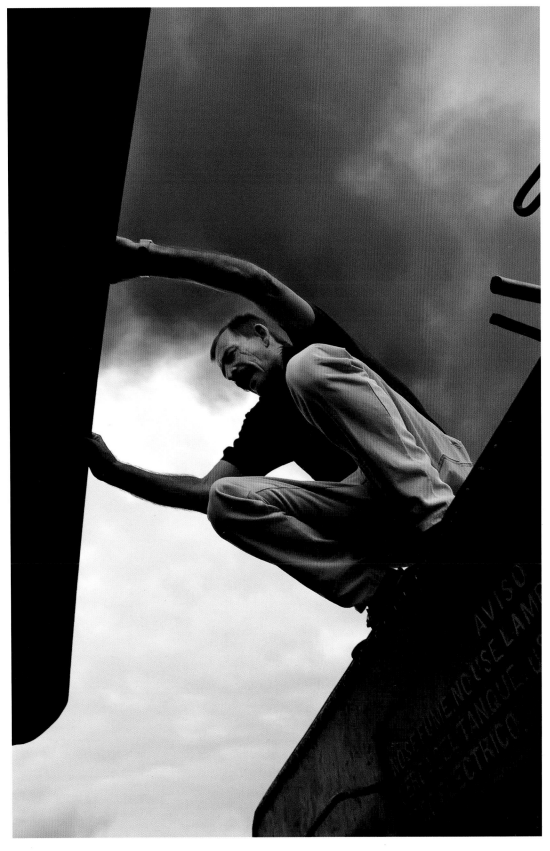

On a steam train | Bruno Walther

Take yourself to market

Markets are always great places to head for when looking for people shots. The atmosphere, facial expressions, colours and textures afford plenty of opportunities.

p61 On a steam train
Cuba

Bruno Walther

p63 Weaver
Institute of Tibetology, Gangtok, Sikkim, Tibet

Paul Tomlinson

p61

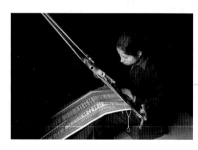

p63

Inspiration: During a steam-train ride from Manaca Iznaga to Trinidad in Cuba I was given the chance to stand on the locomotive. I was busy taking pictures of the driver and engine, but at the same time alert to any photographic opportunity that might present itself along the winding way. All of a sudden a man appeared on the roof of the tender. He spoke a few words with the driver and disappeared again very quickly.

The situation: I was attracted by the perspective and the dramatic appearance of this person against the smoke-filled background. My shooting position more or less mirrored the person's position, as we were both in a relatively unstable position on this shaking train, which was in full motion. He was bent over while I had to recline on my back. He was holding onto the locomotive while I tried to stabilise myself with my feet as I had no hands free.

Camerawork: Nikon D100 with Nikkor AF-S 18–70mm f/3.5-4.5 G lens at 18mm, ISO 800, 1/60 sec at f/11.

Post capture: Lightroom for RAW conversion, dust removal and local exposure enhancement (to make the inscription on the plate visible). Noiseware for noise reduction.

On reflection: *There was no time available for any consideration or fiddling with camera settings, nor any room for changing my point of view.*

Inspiration: On my first day in Sikkim I visited the Institute of Tibetology to see traditional crafts and dancing – there was much to see but a confusion of photographic subject matter. In these situations it is necessary to do some quick visual editing and home in on just one subject rather than be confused by the plethora of activity. I chose to watch the weavers.

The situation: The girl was sitting near a window and her work was illuminated only by natural light. By this time other photographers were gathering around but all encumbered by tripods – necessary for some of the lower light subjects. To achieve a composition which was simple and brought attention to the girl's face and hands was not easy since tripod legs were beginning to appear everywhere, but using the camera handheld and with a slightly higher ISO gave me the flexibility to move quickly and capture the girl's concentration.

Camerawork: Canon EOS 5D with Canon EF24-105 f/4L lens at 40mm, ISO 200, 1/160sec at f/4.

Post capture: Tripod legs and pieces of weaving equipment were distracting items in the background so a little cloning and darkening improved the image and concentrated the eye on the subject. Photoshop CS3 and Nik Viveza allowed these detailed improvements.

On reflection: *I love this image and can't think how I could improve it.*

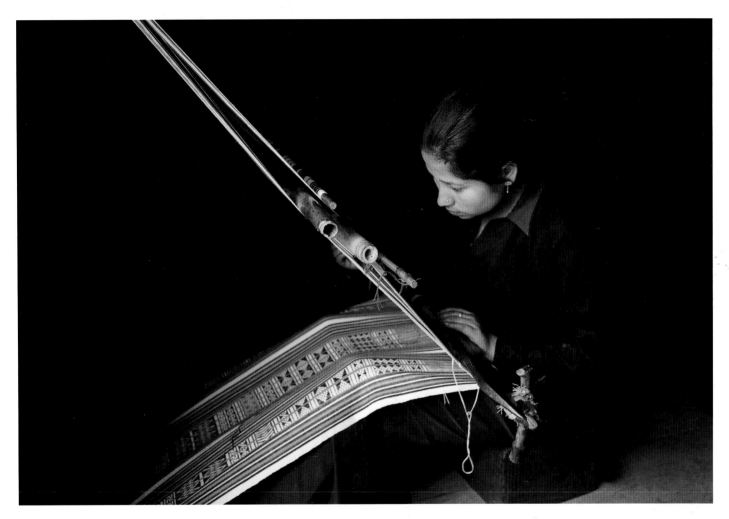

Weaver | Paul Tomlinson

Choose your moment carefully
Staying calm, keeping an eye open for the best characteristics in your subject and having the confidence to wait for the right moment will invariably lead to a poignant and successful image.

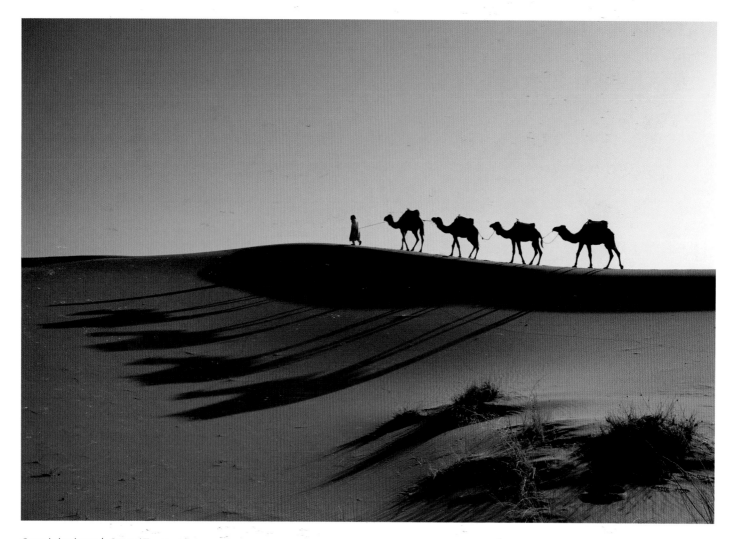

Camel shadows | Carmel Teusner

Use the light you're given

Bright overcast conditions provide the classic light for portraiture, but try to be creative and make the most of directional lighting, silhouettes and shadow.

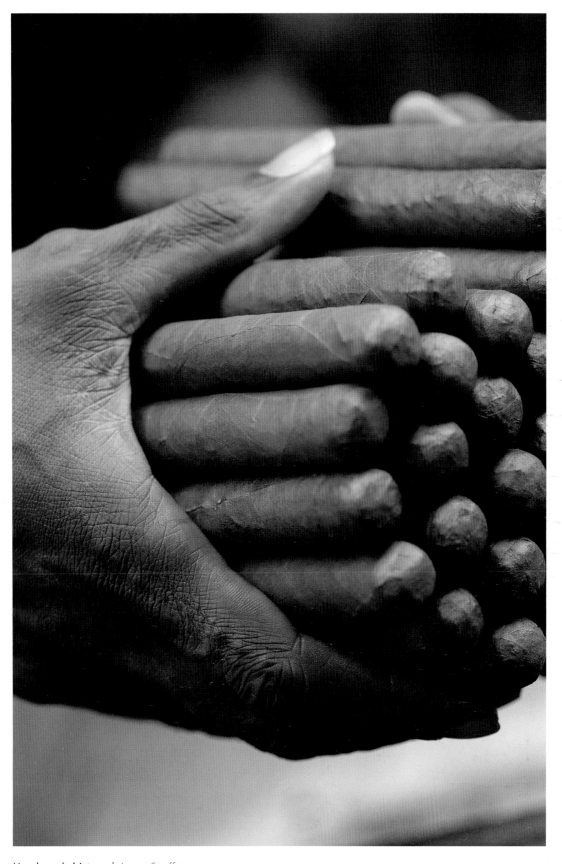

Hand-made history | James Straffon

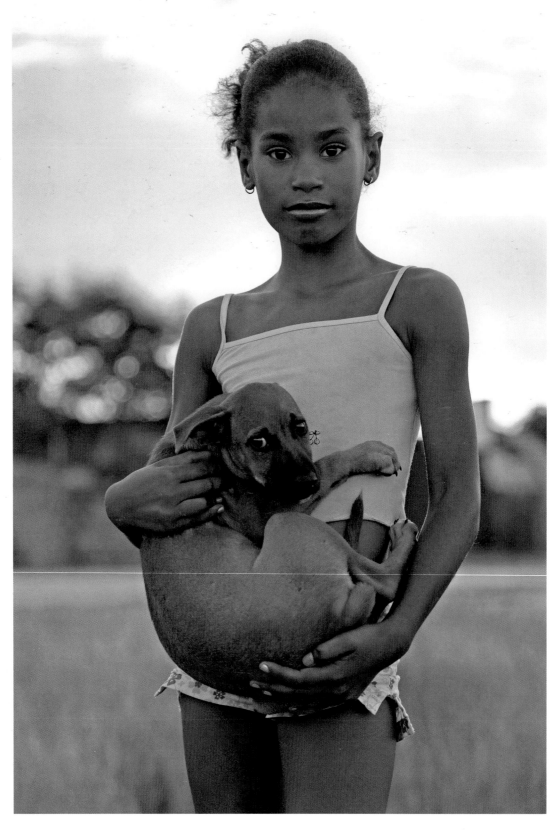

Girl and her dog | Jean-Luc Benazet

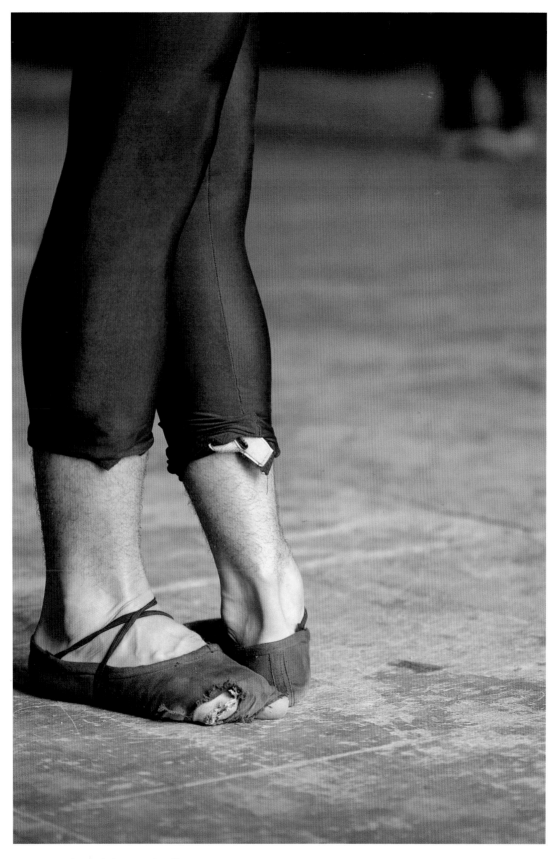

Dancing in the dark | James Straffon

Search for the similarities

There might be language barriers and cultural barriers, but you'll have more things in common than not – it's just up to you to find them.

p64 Camel shadows
Erg Chebbi, Morocco
Carmel Teusner

p65 Hand-made history
H Upmann Cigar Factory, Havana, Cuba
James Straffon

p64

p65

Inspiration: The location itself was inspiring – riding a camel to the top of the dunes and watching the sun rise. I wanted to capture some of that magic, the vastness and tranquility, in my images. I admire the work of Yann Arthus-Bertrand and was inspired by his images of camel caravans in the dunes. I had a very clear idea of the kind of picture I wanted – silhouettes, long shadows and warm tones.

The situation: There was a window of opportunity as the guide brought the camels to take us back down. The difficulty was the angle of the slope and the angle of the sun. I was trying to capture the silhouettes and the shadows without going too close to the sun. I underexposed the camels by two stops and had to work fast to get the composition right before they moved out of shot.

Camerawork: Canon EOS 5D with 24–105mm IS USM lens, ISO 100, 1/640sec at f/8.

Post capture: In the RAW stage I lifted the exposure by a third of a stop and increased the contrast. I cropped the image a little to remove some distracting grasses from the foreground as well as some flare on the right. I also applied a slight boost to the colour temperature and shadows. After the RAW stage I also adjusted the highlights a little.

On reflection: *I think I succeeded in capturing the sense of space and tranquillity, and feel the picture has some interesting lines. In hindsight a smaller aperture might have been better and I could probably have experimented with different angles and made more use of the foreground.*

Inspiration: Production of fine cigars is a very human process, and the extreme care and skill of the top-floor practitioners at the Upmann Cigar Factory had a very benign quality. Here, we found this upright, athletic, almost statuesque male worker handling the fruits of his labour with a paradoxical sensitivity and tenderness.

The situation: I made it my intention to circle the subject before choosing my spot – a low angle, framing the space which interested me. Perhaps by accident, I discovered it is best to spend more time looking, and less time firing the shutter. When time is short, one good shot is better than many mediocre ones. Here we had good, soft lighting above, and a willing subject.

Camerawork: Canon EOS 400D with Canon EF 100mm f/2.8 Macro USM lens, ISO 400, 1/160 sec at f/2.8.

Post capture: This was originally a colour image – I used Photoshop to first completely desaturate the colours, then brought in a warm sepia, via an orange filter, set to Soft Light.

On reflection: *My aim was to blur the difference between the flesh of the hand and the fabric of the cigar. They seemed to share similar qualities of skin and form. More than a bunch of fives. Sadly we were pressed for time, as I would have liked to create a series of shots based around this one composition – 'Factory workers' hands'.*

Photographic education

The camera gives us the perfect opportunity to see and learn, and to have a visual, internal 'conversation' with new places.

p66 Girl and her dog
Bay of Pigs, Cuba
Jean-Luc Benazet

p67 Dancing in the dark
Taetro Garcia Lorca Ballet School, Havana, Cuba
James Straffon

p66

p67

Inspiration: Travelling between Vinales and Cienfuegos, and tired after an eight-hour journey, our driver decided to stop to get some petrol in a remote village. We were told not to go far as it wouldn't take long. On the approach, I had noticed a basketball court that reminded me of the old USSR. The urban landscape was desolate, and I was drawn to it.

The situation: As I reached the court, this beautiful girl and her dog came out of nowhere. She was looking at me, and seemed to be play-acting for the camera. The dog was like a puppet for her, and it did not seem to mind, but looked a bit frightened. She said she didn't mind having her photo taken, and I was rewarded with a magical moment in the sunset, where she stood still and looked at me, holding the dog like a baby – which looked straight at the camera too. Magical.

Camerawork: Nikon D2x with 70–200mm VR f/2.8 lens, 1/5000 sec.

Post capture: I have added some exposure to the image, as the sky was becoming dark. I didn't have the time to reach for my flash to add some fill-in as it all happened so fast, and I much prefer the natural look anyway.

On reflection: *This image is the perfect example of a chance encounter. The central character, the girl, just danced around me with her dog as I fired away. This must have lasted five minutes, but it felt like ages.*

Inspiration: I was confined to a narrow corridor of space, in which to capture the subject. Within this, I found a floor-level eye line that allowed me to tell the story I wanted to focus on – the threadbare environment from which such beauty arose. Here was history. The rough, timeworn floorboards; numerous, scarcely practical slivers of fatigued footwear; and yet such pride. A metaphor for Cuba, perhaps.

The situation: I wanted to frame isolation and contortion within this crowded rehearsal room. So, laying on the dusty boards, I selected a prime 100mm macro lens, stopping down to f/2.8. Additionally, I felt the framing of the subject should place the dancer to the left, allowing the light to move in from the open window to my right. An almost vacant space would then occupy and balance the remaining half. Among all the pirouettes and pliés, I wanted to capture stillness and poise.

Camerawork: Canon EOS 400D with Canon EF 100mm f/2.8 Macro USM lens, ISO 400, 1/320 sec at f/2.8.

Post capture: Using Photoshop, I slightly desaturated the image, leaving enough Chroma to keep the picture in the real world.

On reflection: *I set out to illustrate the reality of dance – with its wear and tear on the dancer. I also wanted to highlight the conditions in which these young Cuban hopefuls existed. The end result speaks for itself.*

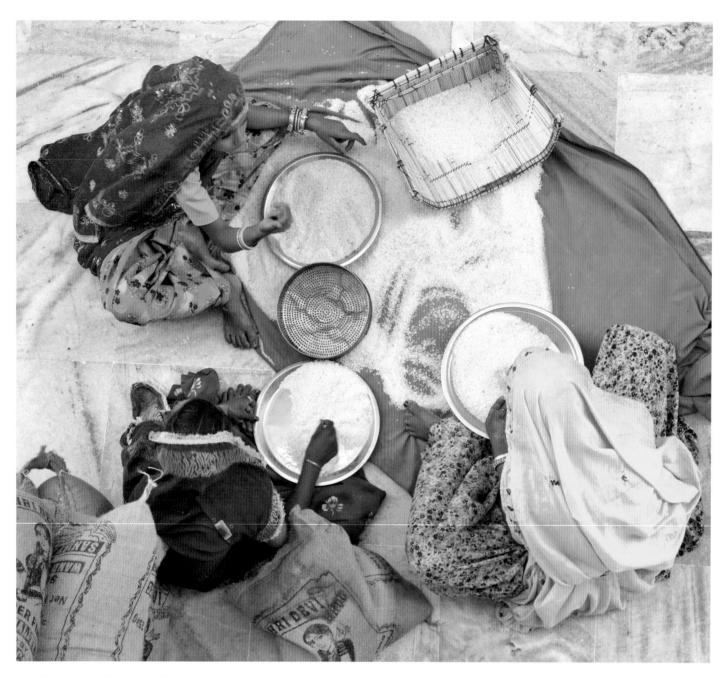

Girls cleaning rice | Adrian Hollister

Be sensitive to others

People nowadays are much more aware of how their picture might be used, and that can sometimes influence whether or not they want to be photographed.

p70 Girls cleaning rice
Rajasthan, India

Adrian Hollister

Top Tips

p70

Inspiration: I had taken an afternoon off from travelling and sightseeing in Pushkar, before going to the famous camel market in the evening, and was sitting by the swimming pool. Rajasthan is so full of colour (as well as people) it was difficult to put the camera away.

The situation: I went for a wander and, looking over a wall, saw these girls sorting the rice. The colour of the material they were working on and their headdresses against the grey of the floor tiles made this a must-have picture. I rushed back to my seat to get the camera and took this image before one of them looked up and noticed me. Feeling a little guilty at taking the picture discreetly I went down to see them, gave them a few rupees and took some more pictures – none of which compared with this one.

Camerawork: Canon EOS 20D with Canon EF 28–200mm f/3.5–5.6 USM lens, ISO 200, 1/45 sec at f/8, and ISO 200.

On reflection: *The slow shutter showed the movement of the girls' hands as they sifted the rice, which I think is very effective. The downside is that the face of the girl on the left is not sharp, On balance, I feel that was a worthwhile compromise.*

1. While telephoto lenses are best avoided for candid photography, as they can make you appear furtive, they are ideal for blurring a background that might otherwise be fussy and distracting.

2. Never buy a completely new camera system before embarking on the trip of a lifetime. Your best pictures are made only when you know your kit inside out.

3. Colour is very seductive, but it can also be distracting and create confusion, so take care with how it works within the frame.

4. Stick to the lowest ISO setting you can. Although increasing the ISO can rescue a situation, in some ways it's a lazy approach to take, so don't be tempted to ramp it up unless it's absolutely necessary.

5. Panning is one of the great creative tools in photography, but practice with different shutter speeds and on a variety of subjects in order to obtain an idea of the effect it will have on your image. **PH**

CLIVE MINNITT

Learning to observe

I am addicted to travel – and I'm a great believer in it being extremely good for us. The inevitable ups and downs that accompany a trip overseas teach us to cope with almost all eventualities, and to be adaptable, both as photographers and as travellers. It's the element of the unexpected that always proves so exciting and these moments are invariably centred around people. Meeting and observing people are often what make a trip worthwhile. Photographing them helps us to understand more of the local culture, in addition to creating a visual and historical record.

Candid people photography requires a certain kind of confidence. To take close-up candids you need to have an acute ability to anticipate the situation and how it's going to build, then react to it at the crucial moment. You have to be bold yet discreet. However, there is a danger with candid photography that if you only take pictures with long lenses you will distance yourself from the subject and become an observer rather than a participant.

Background detail

When photographing people, it's quite understandable that your concentration will be focused almost wholly on the individual – or group – on whom your lens is trained. But, however important their part in the picture, they aren't the *whole* picture. What's going on in the background is almost as important as your main subject. Busy clutter is distracing, meaning the viewer's eye will wander and have trouble settling on your intended main focus. You have to think extremely quickly, but you should also be considering how the colours in the composition are working together. If they contrast with each other, is the clash of tone and hue effective or distracting?

It's also worth being bold, and experimenting with a range of styles and approaches. While photographing an individual against a plain background can produce a strong, compelling image, you might also want to consider looking for interactions between the person and their environment, creating a sense of place so your viewer knows where you were and why you chose to take that particular photograph. You might spot an individual within a group who is doing something different from the rest, or who is wearing a different colour from those around them. Watch through your viewfinder for the moment at which everything comes together and, if you are using a zoom lens, avoid constantly zooming in and out of the scene, as this is a surefire way of missing the decisive moment.

Careful composition

Another compositional element I always look out for is a rather unexpected one: lead-in lines. People tend to think that lead-in lines are only relevant in landscape or architectural photography, but they aren't. They can be utilised in almost any genre, and can be your best friend. A lead-in line might come in the form of a railing, an →

Be open to change

If you can't see a picture, simply turn round and look the other way: be adaptable and ready to respond quickly, because it only takes a split second for things to go from appearing hopeless, to a photograph developing in front of your very eyes.

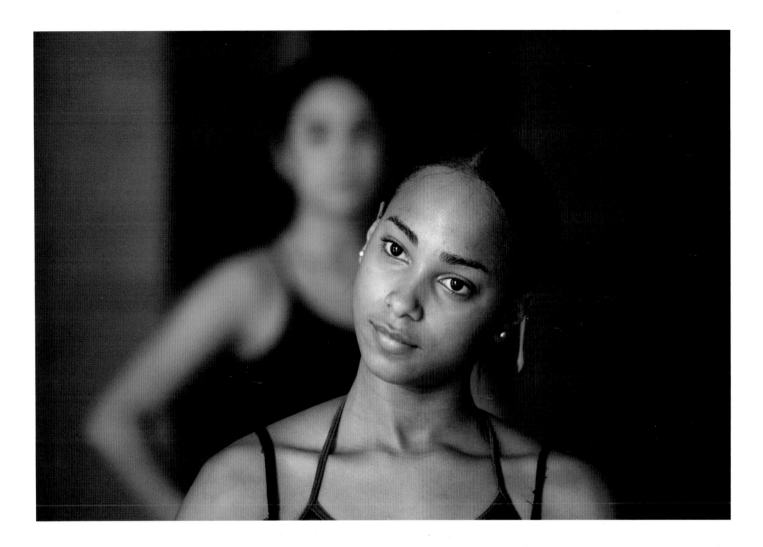

National Ballet School, Havana, Cuba | Clive Minnitt

The building that houses the National Ballet School is palatial but dilapidated. There is no artificial lighting, so all photographs have to be taken only with the available light. It can be very atmospheric, and I wanted to reflect this, so set my camera to shoot in sepia, and used a long lens which threw the background out of focus, and captured the attentiveness of this girl as she listened to her teacher.

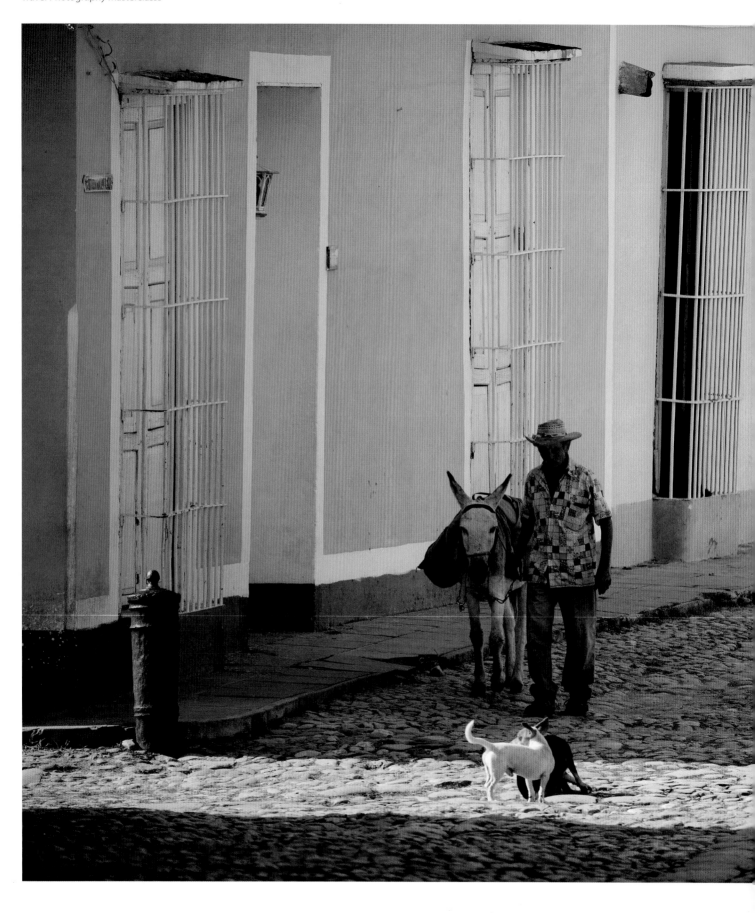

Man, donkey and dogs, Cuba | Clive Minnitt

If this man had been much further to the right, he would have been too far away from the dogs. I managed to capture him as he was positioned between the railings in the background. The light was lovely, but the sky uninteresting, so I chose not to include it in the frame.

outstretched arm, a shadow, a shoe – almost anything that takes the viewer into the most important focal point of your photograph.

Taking your first serious people picture is rather like jumping into a cold swimming pool – you can find yourself putting it off because it's slightly scary! It is good practice to get into the rhythm of photographing as quickly as possible – even if it's creating images of the residents or staff in the hotel where you're staying. A lot of hotels have a great deal of character, and their décor often lends itself to photography. Combine that with the variety of faces and characters you encounter in these sorts of places, and your first photographs should be easy to find.

Taste of freedom

Photographing people frees you from the shackles of the tripod. A great deal of my images are made using a tripod. Sometimes it makes a refreshing change just to leave it behind in the hotel room and head out with the aim of shooting a bit more spontaneously. It's also a useful discipline to restrict yourself to just one lens. Not only does it enable you to move quickly, unencumbered by the weight of several different optics, but it also allows you to capture a shot that you might have missed if you were changing lenses just at the crucial moment. Normally I'd stick to my 24–105mm lens for candids, as the wide end is ideal for groups or for getting in close and tight to the subject, while the longer end is the classic portrait focal length. The apparent shallower depth of field means the background can be rendered softly, and your subject isolated from it.

The road less travelled

Researching your destination for photographic potential is always a good idea. However, don't get too bogged down in guide books and information on the internet. If I can – and depending on how much time I have – I prefer to venture off the beaten track. Little-known, tourist-free villages invariably provide more willing subjects and visual treats than their more publicised neighbours. This personality trait stems from my parents; my father always refused to go the same route twice. For him it was a case of the narrower the road the better – and if it had grass in the middle, then it was better still. It's an approach I would recommend to any traveller, novice or otherwise, remembering to take sensible safety precautions of course.

A local guide can be invaluable in helping you reach places that other photographers might not get to. Not only do they know the right people to talk to, but they are usually happy to discuss the politics or social situation of their country and you'll learn things you would never hear about otherwise. This sort of background research is not only fascinating, but it can also influence your photography, either subconsciously or perhaps even overtly enough that it gives you a unique idea for a project to pursue.

The crux of people photography is learning to observe and to experience. While your backdrop might be a barbershop, a church, a quay, a festival or a beach, don't let this distract you from the main reason for the picture – to convey emotion. Because you are in a country different from your own, what you see appears more interesting. For the locals, however, it's their everyday lives. Once you come to appreciate that, you might learn to enjoy being back home a bit more. ■

The essential qualities of a picture

In many ways, people photography is no different from any other form, as we are still looking for graphic images, with shape, colour and emotion. All these things are possible, as long as the overriding consideration is for the person you're photographing.

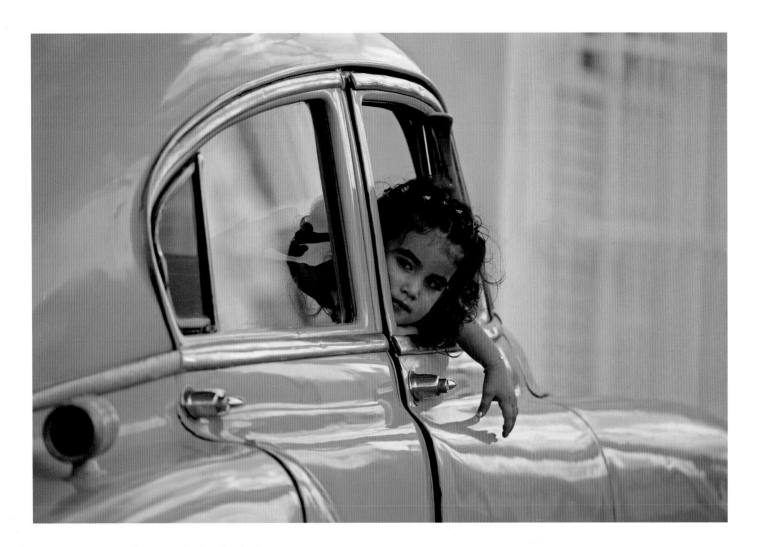

Trinidad, Cuba | Clive Minnitt

For me, this picture is made by the girl's arm hanging out of the car window. It's also a case where including only part of the car worked better than it would have if I'd featured the whole, because it concentrates the attention on her face. The car's curves lead to her, and she would have become lost in the frame otherwise.

ABOVE: **Girl on window ledge, Trinidad, Cuba** | Clive Minnitt

Trinidad is a UNESCO World Heritage Site, and is simply full of subjects for photography. Very often people are quite happy to be photographed, and if I can find out where they live, I try to send them prints or take prints to them on a later visit. I always try to take two or three frames in situations such as these, but rarely more. It's important not to use the scattergun approach; to reduce the number but improve the quality.

LEFT: **Forcalquier, Alpes de Haute-Provence, France** | Clive Minnitt

While in Provence doing a recce, I spotted these fields near the hotel where I was staying. The polytunnels created a patchwork of interesting lines in fields – but the top part of the frame needed something extra, which the person provided. I used a long lens, but would have liked to get closer still.

St Paul's Carnival, Bristol, UK
Clive Minnitt

This picture was taken rather closer to home, but Bristol is still a travel destination for those who live outside the area! Working very quickly, I took three shots, but only one was successful because the others had too much going on. The van stopped only for a split second so I had to react fast, but be controlled with the cropping while filling the frame.

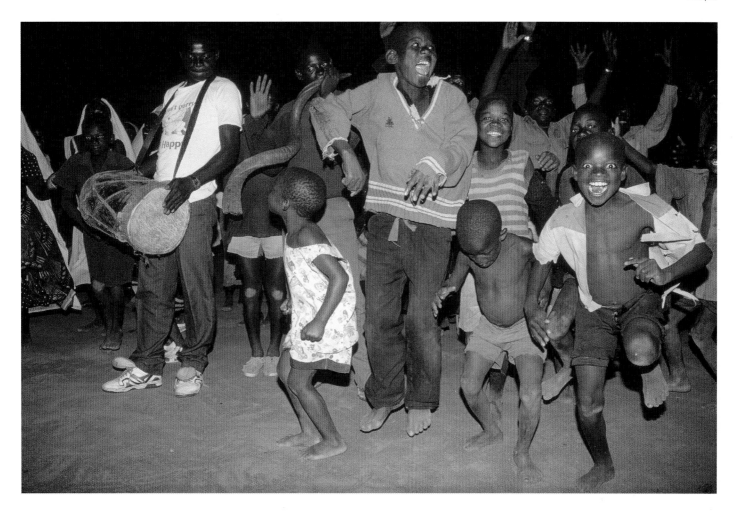

Case Study | Clive Minnitt
Children dancing, Zimbabwe

In 1993 I wasn't yet a full-time photographer but I was becoming increasingly interested in the subject. A good friend and I went to Zimbabwe to spend three weeks with a cousin who was working there as an agricultural consultant. My cousin took us to an area in the southern part of the country to visit a remote village where he knew a few of the locals. The people were extremely poor, and had very little food. So we wouldn't make their plight any worse, we took several bags of wheat with us, which they kindly accepted and ground into flour to make bread so we could eat. We felt very welcome and, one evening, three villages came together to dance for us. It was completely dark, except for a fire, but it was still possible to tell that there was a great photo opportunity. I had no option other than to use flash. It wasn't until I got home that I realised how fantastic the expressions were on the

faces of a couple of the kids. One of the pictures went on to sell quite well at fairs and markets, so I asked my cousin how I might go about helping the family of the children. It turned out that, during the months prior to our arrival, 175 of their 200 cattle died in a drought. Not long after, 20 were stolen – and the five that remained were female, so couldn't breed. The money from the sales of this picture enabled them to buy a bull and start building up their herd again. All because of one picture lit with a single flash. As a postscript, the same picture was one of a batch stolen by armed robbers in a Post Office raid, when I sent off 21 transparencies to have 77 prints made up to sell. I had insured them for consequential loss of earnings, so I was able to claim compensation – but it does mean that the picture you see here is a slightly different version of the one that helped make life a bit better for a family in Zimbabwe.

CHAPTER 3 : **ARCHITECTURE**

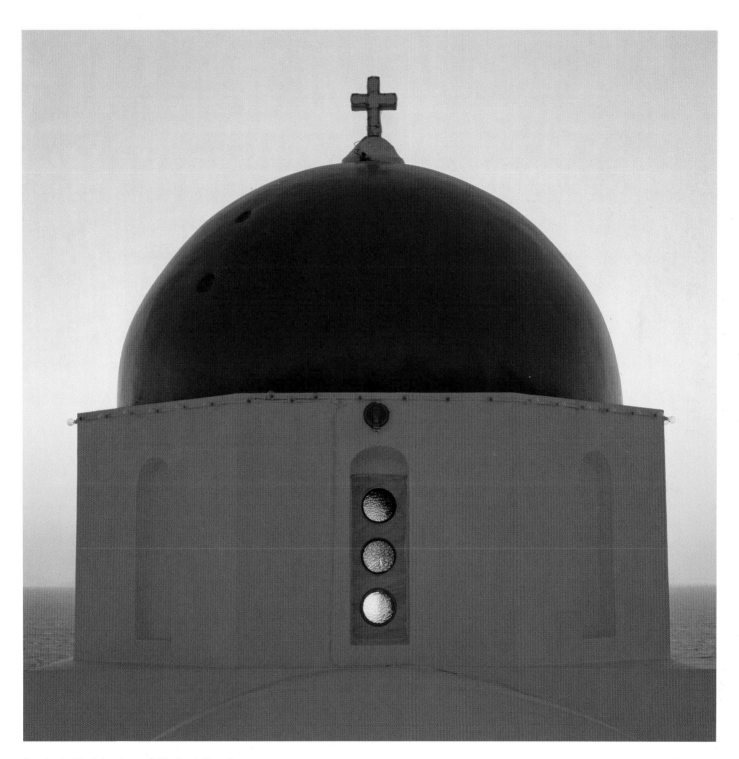

Sunrise behind the dome | Elizabeth Restall
(See page 156 for technical details)

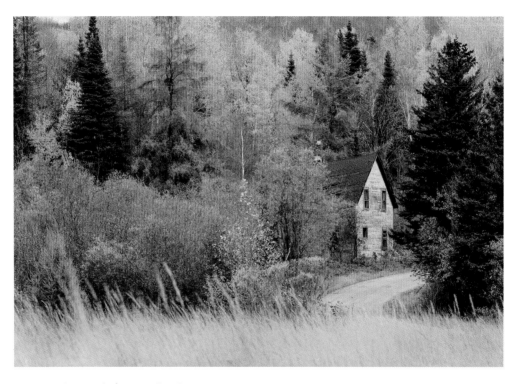

House in the woods | Brian Whittaker
(See page 156 for technical details)

Introduction

Architecture oozes history. Buildings – be they simple adobe huts in Africa, elaborate Venetian palaces, or gleaming modernist structures in a city's financial district – tell the story of a country or region's development, and reveal much about its geography, economy, society and culture.

Solitary structures in the landscape tell as much of a story as a city's skyline and, as with all aspects of photography, it's the interaction of light with these creations that brings them to life as images. Interpreting the intention of the architect is one of the many challenges of architectural photography, but try to steer clear of a literal record of a subject. Instead, look for relationships between light and shade, straight lines and curves, shapes and tones, old and new – all help to make sense of how a building interacts with its environs. **AMc**

JOE CORNISH

Make it new

The problem with so much commissioned travel photography is that, very often, publishers use it to reinforce our preconceptions. The sun is shining, the sky is blue; everything is picture perfect. In the past, most of my travel photography work was commissioned along these lines; I was obliged to produce images free from any obscure angles, unusual lighting or uncommon subjects. The brief was to make glorious representations of things we all already knew. Creatively speaking, this can be a stifling way to approach any area of photography. Nowadays, I deliberately seek to see things afresh – especially if it's a subject I know well. It's important for me to steer clear of the predictable solution.

So how does a photographer go about this? I don't know the answer; I guess it is different for everyone. Looking at travel photography specifically, this is simply what we respond to when travelling with a camera – in fact, it is photography that makes the rigours of travelling worthwhile for many of us; literally it is why we travel. But what we respond to will vary – that's what makes our photographs personal after all. The great thing about travel is that it gives us a chance to see new things… new people, new places, buildings, landscapes. The challenge is, to paraphrase the famous saying, can we see these new phenomena with new eyes?

The contradiction that arises from so many travel photographs is that, while the subject matter may be new for the photographer, the photographs look all too predictable. To produce successful images we need to find a way of reflecting our sense of novelty and wonder in the place, and the moment. That way, travel photography becomes a personal journey, not just a packaged tour.

The observer

If there is a polarity in photography, it's the difference between that which we control – such as the studio still life – and the documentary. The documentary photographer witnesses the world as it is. As a landscape photographer I consider myself an observer, someone who bears witness to the landscape as it is. I also shoot quite a lot of architecture, and technically and creatively there's a lot of common ground between architectural and landscape photography. I apply the same lighting approach to architecture as I would to a landscape. Light is the language and the raw material of photography – we may need enough light to reveal the subject but what we really need is to understand its language. That is, qualities of light and shade, contrast and colour, and revealing or concealing detail. As documentary photographers we have limited – if any – control of light, but we have some control of the moment at which we open the shutter. That can make all the difference to the light.

The nature of architecture, however, suggests we are photographing an object; a building can be considered a very large still life. I still find this concept useful for lighting analysis, but I try to avoid the 'objectification mentality'. In the past I thought viewpoint was all-important. There is a lot of truth in that, but now I focus on exploring the →

Ducal Palace, Urbino
Joe Cornish

This is an idea originally made on the 6 x 6 cm format in 1989 and executed on 5 x 4 in 15 years later, with a lot more time devoted to alignment and geometry. Suspending my beloved Ebony over this 30m-high void was nerve-wracking, and visualising through the ground glass somewhat tricky. Given the logistical challenges, I was happy to capture some of the rhythms of the natural world, which I am sure the architect intended with this beautiful staircase.

Toledo | Joe Cornish

The paintings of El Greco are famous for their intensity of feeling, and although he was a figure painter first and foremost he tackled landscapes too, unusually for this period of art. This view of Toledo, the city in which he lived and worked, is a homage to El Greco, taken as it was from the same perspective he immortalised on canvas in the late 16th century.

visual relationships the building might suggest to me – taking into account colour, texture, shape, mass, line, energy, balance and so on. That's a fundamental aspect of how I now work with photography: on a formal visual level I hope my photographs can be enjoyed as an abstraction. The literal content is simply one aspect of the photograph.

Seeing with fresh eyes

A tip frequently offered in photography magazine travel articles is to buy postcards of the area we are visiting, and photograph at these 'postcard' viewpoints. I disagree, as it only arms the travelling photographer with preconceptions and unrealistic expectations, and these frequently have a negative effect. I think we should aim to see a place for how it is in the reality of 'now', rather than trying to recreate an idealised image on a postcard. If I am travelling to some unfamiliar new place, however exotic it may be – Chile's Torres del Paine, Wadi Rum in Jordan or Antarctica for example – I would still apply the same artistic values, standards and principles that are true for me. I still try to challenge myself in the realms of timing and composition, and perhaps try to avoid the obvious solution, the predictable angle.

Wherever you are, there's only one way of getting to the heart of a place, and that's to get out and walk. To know your environment you have to walk in it. I do anyway! You may have a map, but there's no need to become preoccupied with a predetermined route; have confidence in your own judgment and go where instinct takes you. If I am with a companion I cannot concentrate fully on the visual experience if I am talking. I need to simply walk, watch, and be quiet. Once attuned to your environment in this way, the photographs will start appearing. A camera can help you develop a heightened awareness of your surroundings. In a sense, it's a meditative process – it's certainly a good way of encouraging a connection with what's there, and to cultivate a receptive state. (Of course, talking with local people is also always good!). Once you are in that open, receptive psychological condition, you are better able to distil the essence of where you are.

It's all in the detail

To capture the character of a building you don't have to photograph the whole thing – and you can't anyway, as that would require you to be in several different places at once! Often, buildings are so large and complex as to be far beyond the scope of conventional photography (how can you photograph the Sagrada Familia in Barcelona, for example?). But they can still be a great source of pictures, and a starting point for visual ideas and exploration. I am interested in the context – to see how buildings sit in the landscape, occupy a space, and relate to the buildings around them. But I am also interested in the details.

Working where I live in North Yorkshire deepens my experience and understanding of the environment, through repeated observation and through photographic practice, at all times of the day, through the seasons and over the years. Traveli widens that experience. Much of what I learn about light and nature from home can be applied when travelling. And much of what I learn from travelling helps me better appreciate my local area – because I've been given a fresh perspective on it. In that sense, travel is as much about the returning home as it is about the going away. Travel should be a truly life-enriching experience. ∎

Horses of San Marco, Venice | Joe Cornish
These bronze horses on the porch of San Marco in Venice may not be the originals (which reside within the building) but they make a pretty good substitute. How to photograph them differently? Here I used a Ricoh R-4 compact (well, I was on holiday!) and concentrated on the negative space filled by the sky, which reminded me of a winged bird. The prodigious depth of field of the small sensor camera made this juxtaposition possible. This picture made me realise without doubt that the digital compact is a powerful photographic tool.

Bay Street, Toronto |

Joe Cornish

When I visit a North American city, part of me is still the shameless tourist. A glimpse of the iconic CN Tower in Toronto was the initial inspiration for this image, but what I really fell for was the astonishing reflected light from the building opposite, which created a simultaneous 'with' and 'against' lighting opportunity. As figures moved through that light I experimented with a number of moments – this one captured the essence best.

Silvacane Abbey, Provence | Joe Cornish

I love to stand in the side aisle of a gothic church, and shoot at a three-quarter angle through to the nave beyond. Somehow the play of light and shade, the rhythms and flow of the architecture seem to come alive for me from this slightly more intimate perspective. So this is not an original idea, but the sheer austerity and purity of line of Silvacane Abbey make it a perfect location for this approach.

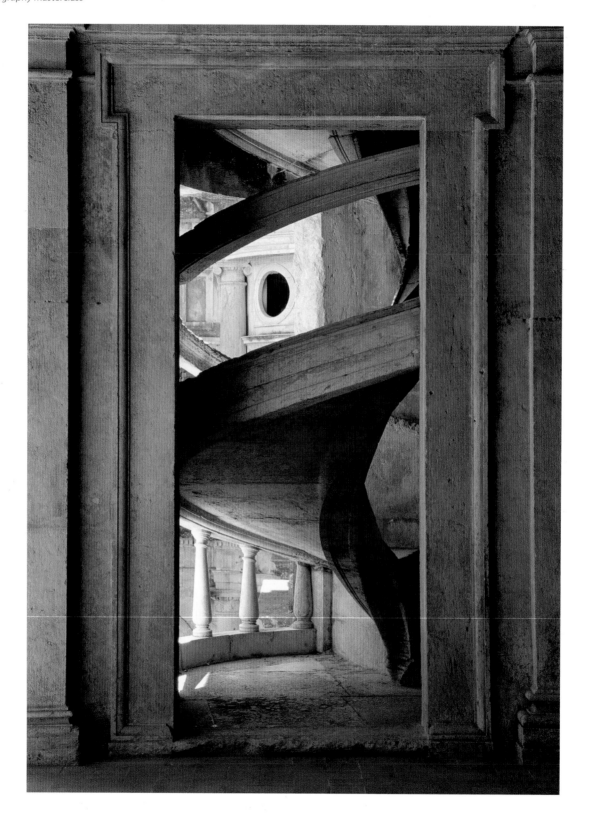

Convento de Christo, Tomar, Portugal | Joe Cornish
This cameo exemplifies the spirit of many architects of this period who, unrestricted by planning regulations and budgets, played with form and light to create witty, whimsical and in this case wholly impractical vistas and glimpses of their work. But what delightful impracticality! This was made with a 35mm film camera.

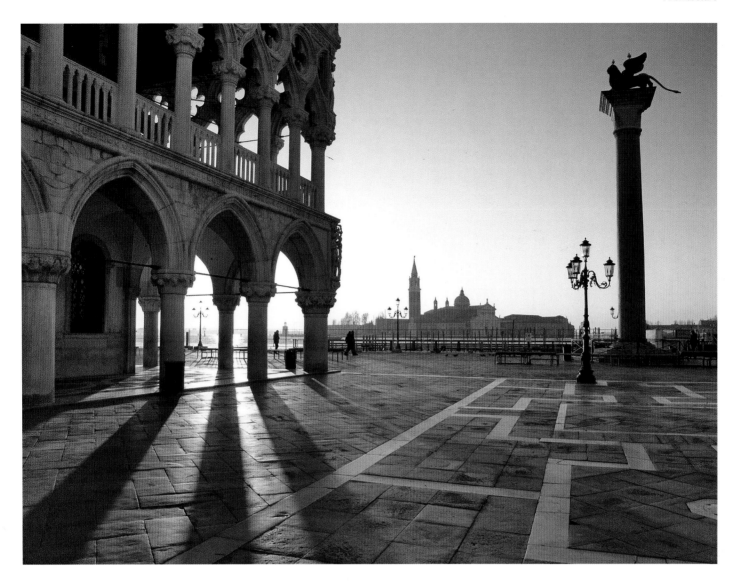

Case Study | Joe Cornish
The Doge's Palace, Venice

..

The Doge's Palace, next to St Mark's Square in Venice is beautiful, but can be awkward to photograph. I was in Venice one Christmas and, although it was a family holiday, I knew I'd want to wander around St Mark's Square at dawn – the only time it isn't occupied by huge crowds. On Christmas morning we got up before sunrise and took a vaporetto to St Mark's Square. It was wonderfully quiet, but a lot of clutter was uncleared from the night before, and the sky was cloudless, making the contrast stark. As a result, I had given up hope of making a useable photograph, especially as my only camera was a digital compact. We were wandering in the Piazzetta di San Marco, admiring the decorative stonework of

the pavement, when the sun broke over the horizon. The shadows it cast interacted with the labyrinthine shapes on the ground – and I had my inspiration. While this formed the initial idea, it is the wider perspective with the Doge's Palace on the left and the huge granite column of San Marco on the right framing the scene that makes a compelling proposition. All of this, along with San Giorgio Maggiore in the distance, makes quite a busy composition, and the clear sky, so unwelcome initially, is a simple foil for the complexity of the architecture. What completes the picture is the reflective power of the rising sun, which imparts a deep gold into the arcade vaulting of the Palazzo.

ARCHITECTURE GALLERY

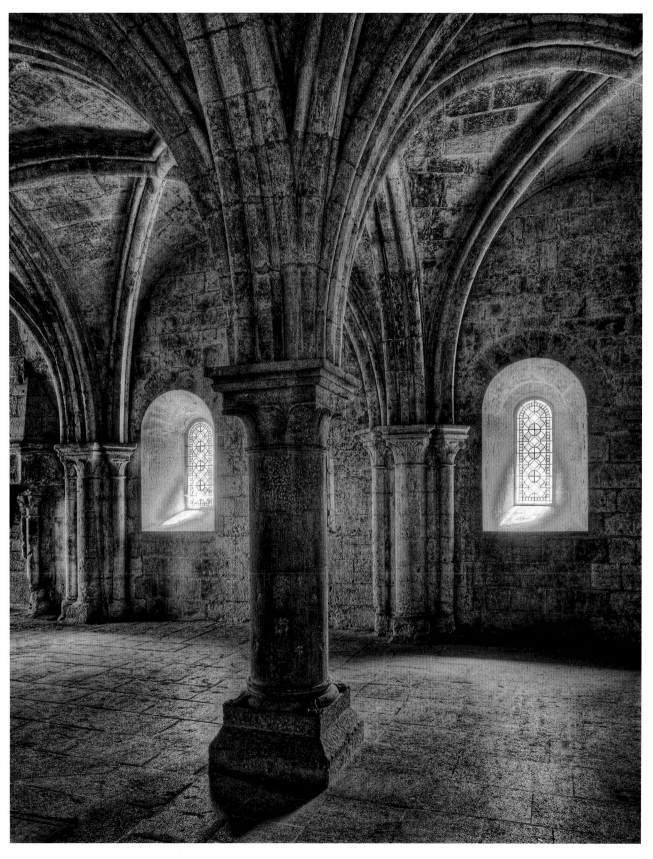

Silvacane Abbey, Provence, France | Sami Nabeel

Keep control

It is important to retain a sense of photographic discipline when travelling – to be controlled and self-examining, and not to get too carried away.

p97 Silvacane Abbey
Provence, France
Sami Nabeel

p99 Kasbah doorway
Telouet, near Marrakech, Morocco
Elizabeth Restall

p97

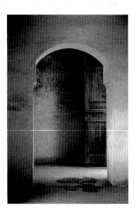

p99

Inspiration: Concerts and music recordings are regularly held at the Abbaye de Silvacane, and during my visit I was delighted to hear a choir practising, making heavenly sounds. I hadn't actually brought my camera with me, as I was more interested in exploring the building and learning about its history.

The situation: Having convinced myself this is was to be a non-photographic stop, I bumped into a friend in the room shown in this photograph. The light from the stained-glass window was lovely, but I knew the contrast range was too great to capture. We chatted about HDR – a new technique at the time – in which several frames of varying exposures are blended to compensate for extremes of contrast, when he suggested I should have a go. I explained that I didn't have my camera with me, but my friend lent me his camera and left me to deal with it.

Camerawork: Canon EOS 5D with 17-40mm zoom lens at 24mm, ISO 100, five separate exposures at f/22, tripod.

Post capture: The five images were opened in Photomatix Pro, converted from RAW and blended to a single 32-bit HDR, then converted to a 16-bit Tiff file using Photomatix tone-mapping software. In Photoshop a pegged S-curve was used to slightly improve local contrast and the final file was sharpened for printing.

On reflection: *To me, HDR images can often appear unnatural because of their lack of extreme light and dark tones, but I hope I've avoided this pitfall here, as the image retains depth in the shadows and detail in the highlights.*

Inspiration: Large, glassless, wire-meshed windows, which look out to an oasis valley below and, in the distance, the Atlas Mountains, illuminated the corridor leading to the doorway. There was no direct sunlight to cause havoc with exposure. The soft colour of the walls attracted me first, then the vernacular archway, and beyond that the crumbling plasterwork of the facing wall. The portion of door, left open to enable visitors to reach the inner sanctum, conveys a solidity that epitomises the Kasbah, a fortress-like building ready to repel invaders.

The situation: A large part of this famous Kasbah is well preserved, with mosaic tiles and highly decorated staterooms on show. Complicated patterns and dark corners, coupled with strong, glancing sunlight, made photography difficult, so I returned to the doorway that I had noticed on the way in. No-one else was there, so I was able to set up my tripod and compose at leisure. I knew it would be my photograph of the day.

Camerawork: Canon EOS 3 with Canon 28–135mm IS lens, Fuji Sensia 100.

Post capture: Using Adobe Photoshop CS2, I adjusted Levels, Saturation, Brightness, Curves and Sharpening in preparation for printing.

On reflection: *I enjoy the colour and simplicity of this photograph, which is very evocative of the Moroccan architecture we saw on our journey to and from the desert. A print of it hangs on a wall in my home.*

Kasbah doorway | Elizabeth Restall

Stata Center | Paul Tomlinson

Reflections | Duncan Locke

Develop your own style

When travelling it's all too easy to become obsessed by goal-driven objectives (eg 'Tuesday, Rome, must photograph the Colosseum/Spanish Steps/Trevi Fountain'); or to imagine our photographs should have a certain look or style to them. But style should emerge from the imagination we exercise in the reality of the moment.

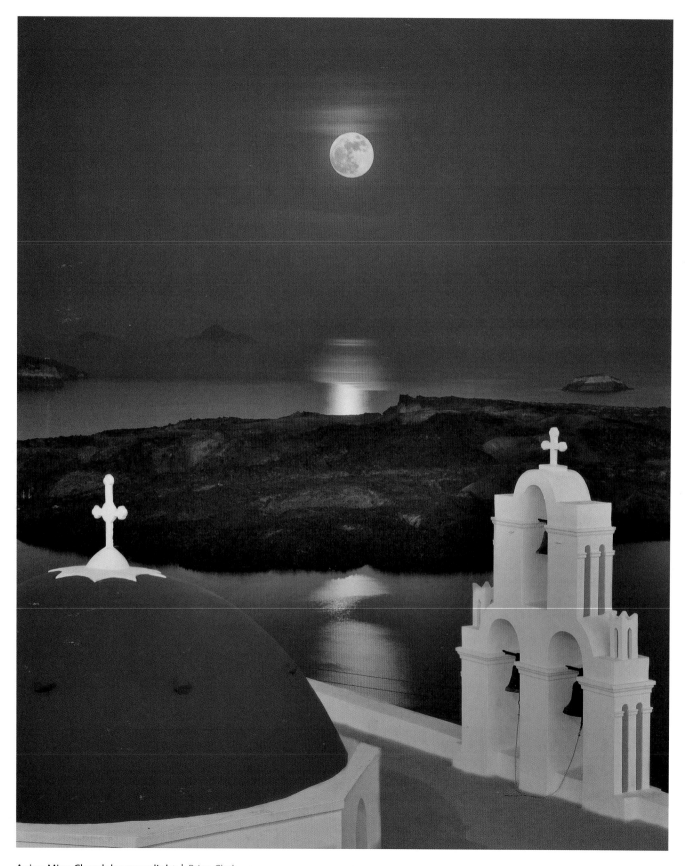

Agiou Mina Church by moonlight | Brian Clark

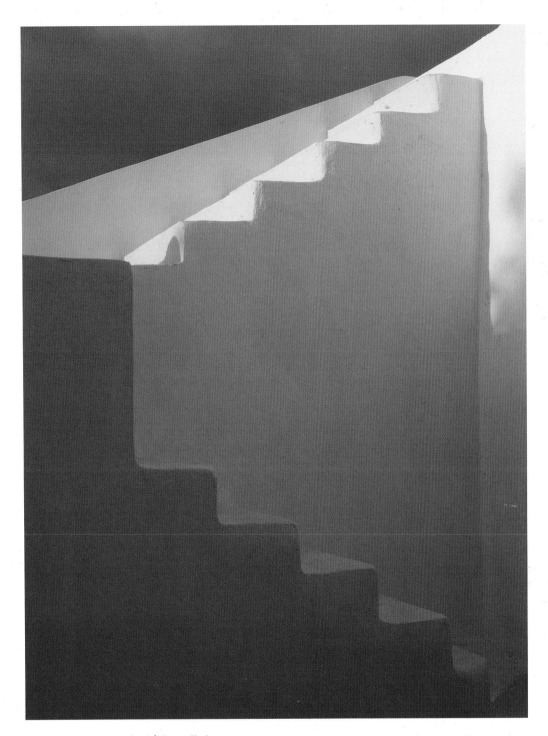

Church stairway near Pori | Brian Clark

Retain an air of mystery

It isn't always essential for the viewer to know in which country a photograph was taken.

Avoid being too literal

It shouldn't be essential to know that these are, for example, the Houses of Parliament, or a piazza in Venice – the photograph should work as a visual experience in its own right.

p100 Stata Center
Massachusetts Institute of Technology, Cambridge, Massachusetts, USA
Paul Tomlinson

p101 Reflections
Kurjey Lhakhang, Bumthang, Bhutan
Duncan Locke

p100

p101

Inspiration: Walking around MIT, I came across this amazing complex of buildings, designed by Frank Gehry and housing an IT research and teaching village. The metal-clad, crazily angled buildings, defying all the norms of architecture, were like a huge work of art.

The situation: Midday light almost always works against the photographer but here the harsh light, sharp angles and bold colour all blended in an unexpected way. The sky was blue but a polarising filter changed it almost to black, throwing the metal-clad building into sharp contrast. There were many colours in the buildings but picking out just the one predominant yellow brought some humanity to the design without causing the confusion which multiple colours may have done.

Camerawork: Canon EOS 5D with Canon EF 24–105mm f/4L lens at 47mm, ISO 160, 1/80 sec at f/18, polarising filter.

Post capture: At the first editing of a RAW file, Lightroom is brilliant for recovering any highlights which have been overexposed. Other than this, there was virtually no additional work on the image.

On reflection: *Patterns and strong colour always attract me and although some people are quite indifferent to this image, there is nothing about it that I would want to change.*

Inspiration: As you enter the courtyard of Kurjey Lhakhang, the monks' accommodation is on the left and the three large temples, or lhakhangs, are on the right, which is also the west side of the complex. The white-painted lhakhangs were strongly lit by the morning light and the reflections in the brightly painted framed windows of the monks' accommodation were too good to miss.

The situation: This was relatively easy photography with good light being reflected on the front of the buildings. Also, the white fronts of these building reflected light onto the painted window frames. The only difficulty was in framing the reflections in the relatively small windows and using an appropriate depth of field to keep the window frames out of focus.

Camerawork: Canon EOS 3 with Canon EF 24–70mm f/2.8L USM lens, Velvia 100.

Post capture: The slide was scanned on a Nikon Coolscan 4000 scanner. Post-processing in Photoshop was minimal with minor adjustments to the Levels and a minimal amount of cropping.

On reflection: *Perhaps the image would have benefited from some stronger colours in the reflected buildings.*

The power of the compact

It should be mandatory for photographers to have a good-quality compact camera in their pocket at all times, in order to make the most of every opportunity that arises.

p102 Agiou Mina Church by moonlight
Agiou Mina Church,
Santorini, Greece
Brian Clark

Inspiration: This church in Santorini was artificially lit and its photographic potential did not become obvious until just before sunrise, when some detail appeared in the sky and in the island background. The moon and its reflection completed the picture.

The situation: The cross on the blue dome, the cross on the bell tower and the moon were the key elements here and I was keen to arrange them carefully in the frame in order to form a triangular composition. It was important to place the crosses within the outline of the island and a 'comfortable' distance from the edge of the frame. The wall supporting the bell tower runs diagonally to the bottom corner and there is some separation between it and the wall below the blue dome.

Camerawork: Nikon D2X with 28–70mm f/2.8 lens at 45mm, ISO 100, five seconds at f/8, Gitzo 1325 tripod, Arca Swiss head, spirit level.

Post capture: The RAW image was converted from Aperture to Photoshop CS3. The dynamic range in the scene was more than the camera's sensor could record and in order to retain detail in the shadows the moon was overexposed. I had made a correctly exposed image of the moon, so I superimposed it on this picture and enlarged it using the transform tool in Photoshop. The shadow detail was recovered using Image> Adjustments>Shadow/Highlight.

On reflection: *I have wrestled a bit with the tonality of this image and am still not sure about it. I think the near islands may be a little too bright. I think the change made to the moon works well and is a fair example of image blending.*

p103 Church stairway near Pori
Pori, Santorini, Greece
Brian Clark

Inspiration: I arrived at this east-facing location before dawn. The church exterior had superb photographic potential but this stairway stood out for its simplicity and the wonderful texture of the whitewashed surfaces. Although I exposed some frames as the sun rose it was not until it started to touch the top of the stairs that the picture came alive, with the light reflecting beautifully off the lower surfaces.

The situation: Positioning of the camera was critical here to provide the most pleasing geometric composition. I decided to shoot from a slight angle from the left with the camera raised up to the mid point of the stairs.

Camerawork: Nikon D2X with 28–70mm f/2.8 lens at 28mm, ISO 100, 1/90 sec at f/5.6, Gitzo 1325 tripod, Arca Swiss head, spirit level.

Post capture: The RAW image was converted from Aperture to Photoshop CS3. A small amount was cropped from the top to remove an unattractive corner of the wall. A slight adjustment in Levels was made before sharpening the Lightness Channel in the Lab Colour mode.

On reflection: *I am a little unhappy about the way in which the top right-hand corner of the bottom steps meets the lowest of the top steps. My eye keeps being drawn to this and I would have preferred to have the corner slightly below rather than slightly above the step. Apart from that, I feel the image could do with another element to provide a more obvious focal point. A black cat would have been nice but there's never one around when you need it.*

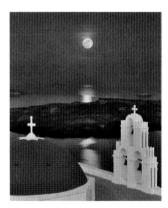

p102

p103

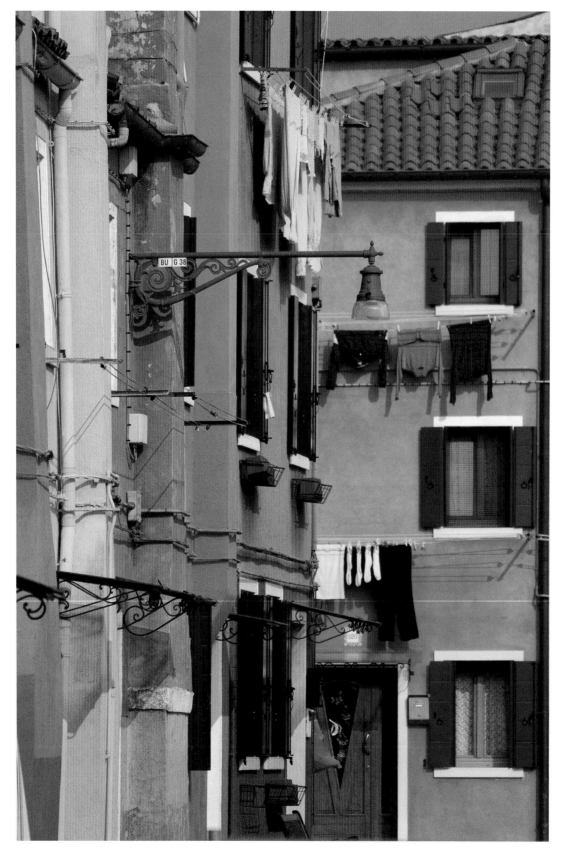

Street colours in Burano | Daniel Valla

Research some things, but not everything

It's always helpful to know something of the history and culture of the place you are visiting but, photographically speaking, you should try to go without preconceptions.

p106 **Street colours in Burano**
Burano, Venice, Italy

Daniel Valla

Top Tips

p106

Inspiration: I could not avoid being drawn in by these saturated contrasting colours and compressed perspectives.
The situation: I decided to use a long lens to accentuate the compression of perspectives. Direct sunlight helped to boost the bright and saturated colours, and the rhythm of the shapes of the walls and washing.
Camerawork: Canon EOS 40D with Canon 28–300mm lens at 170mm, ISO 160, 1/1000 sec at f/5.6.
Post capture: In the Camera RAW settings in Adobe Bridge I applied some changes to Brightness, Contrast and Clarity. I also straightened the perspective of the verticals, using the perspective option of the Crop tool in Photoshop CS4.

On reflection: *It was helpful that the direction of the morning sunlight came slightly from the right, creating the interesting shadows of the wash lines and clothes on the wall. This was fortunate as I could not have taken this picture from another angle, because I was standing on a small bridge with limited space.*

1. Although architectural pictures can be made with any camera, a view camera is still the ideal choice for making distortion-free images of buildings, especially with a wide-angle lens.

2. In the absence of a view camera, perspective control lenses – although expensive – are a suitable alternative. The third option is to use a long lens, as this will minimise perspective distortion.

3. Software corrections can eliminate perspective distortion. However, because this approach is dependent on interpolation, there is a high risk of losing quality, so it really is a last resort.

4. Architects may like their buildings revealed in the clean strong light of the high sun, but optimum mood and colour is often best achieved shooting after sunset when the residue of daylight and artificial lights on the inside and outside of buildings are in balance (also known as 'crossover light').

5. Buildings, bridges and the built environment provide the perfect opportunity for a visual exploration of geometry, line, shape and form. Tuning in to their abstract potential can be the key to making pictures that are something more than merely a documentary record. **JC**

CHARLIE WAITE

Interpreting buildings

I have always felt there are two types of people: those who travel extensively – because nowadays it's extremely easy to – and those who don't travel at all, perhaps because they don't feel the need to meet people from cultures that are different from their own. This is a pity because once we leave our own shores we become individuals, and find ourselves being judged in ways that are different to what we are accustomed to at home. This can be healthy for us, as it gives us a kind of freedom, and provides us with the opportunity to show the best of ourselves.

Travelling also means that almost every moment brings a new discovery, taking us away from the safety of routine or repetition. These experiences can then be expressed through the camera. By and large, they prevent us from being formulaic, and I know from my own travels that I frequently find myself responding to visual stimuli that I would simply pass by at home. While every photographer has a signature that defines their work, being given a photographic jolt is incredibly stimulating, and there's nothing better than a new environment to provide us with that sense of surprise.

Creative constraints

Although I am known primarily as a landscape photographer, I also find the photography of architecture very alluring. The main difference between the two disciplines is that a landscape provides us with pure raw material, whereas architecture is the product of somebody else's imagination, influences and ways of thinking. As such, for photographers accustomed to making pictures of different subjects, architectural photography requires a slight shift in our approach.

For instance, very often, until we come to photograph a building, we don't take note of how it fits into its surroundings: whether it is 'settled' into the landscape around it. This means that usually my impulse to photograph anything architectural is dictated not by the building itself, but by its relationship to the environment – be that urban or rural, hemmed in or standing alone. And usually, our first response to a building is to consider how it might be photographed in its entirety. However, this is rarely the best route to producing an original image, as there's the danger of the picture becoming a mere 'record' of the structure, rather than an interpretation of it.

Reading the architect's mind

So, when it comes to photographing a building, it's not only important to analyse its context, but also to try to find a way into the architect's mind and consider what his or her intentions were when they were faced with a plot of land and their instructions from the client. Only rarely these days is a building commissioned to be built in an environment free from the interference of other structures, so the architect will have been influenced by numerous considerations other than the building itself. Therefore, when we come to photograph it, we need to take into account whether it contrasts dramatically with its environment, or whether it features details (be they subtle or →

Sydney Opera House, Sydney, Australia | Charlie Waite

I had never had much of a desire to visit Australia, as I thought it would be rather ordinary. When I got there I had to eat my words. The Sydney Opera House is the finest piece of architecture I've ever seen. I wanted to convey something of the arcs, so I looked for a foreground that would echo them. The chairs' arms and backs are rounded, so 'talk' to the opera house, and make a gesture towards it. Without them, the foreground shadow would be too dominant.

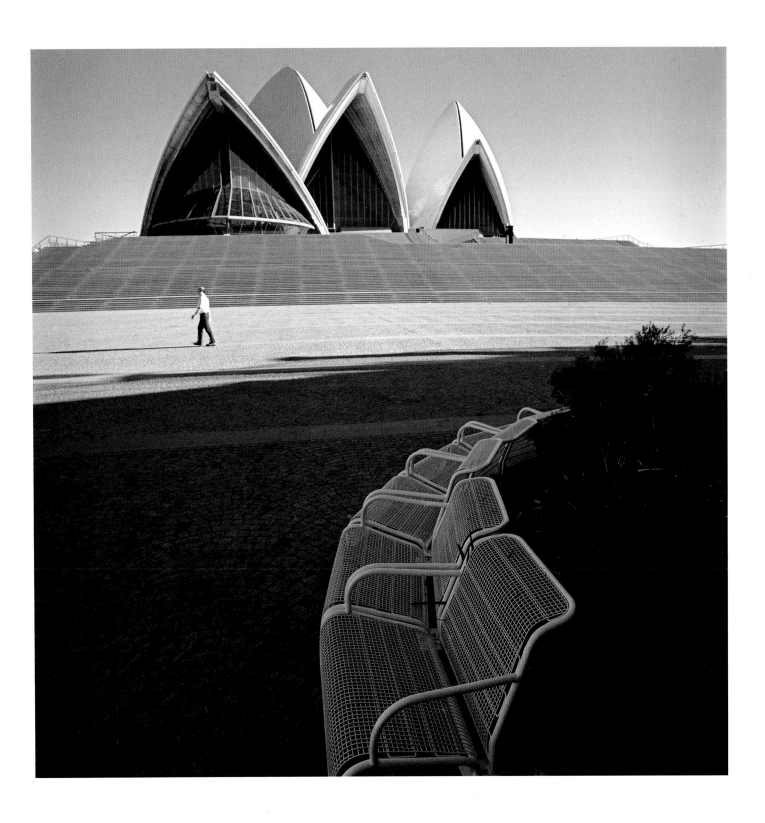

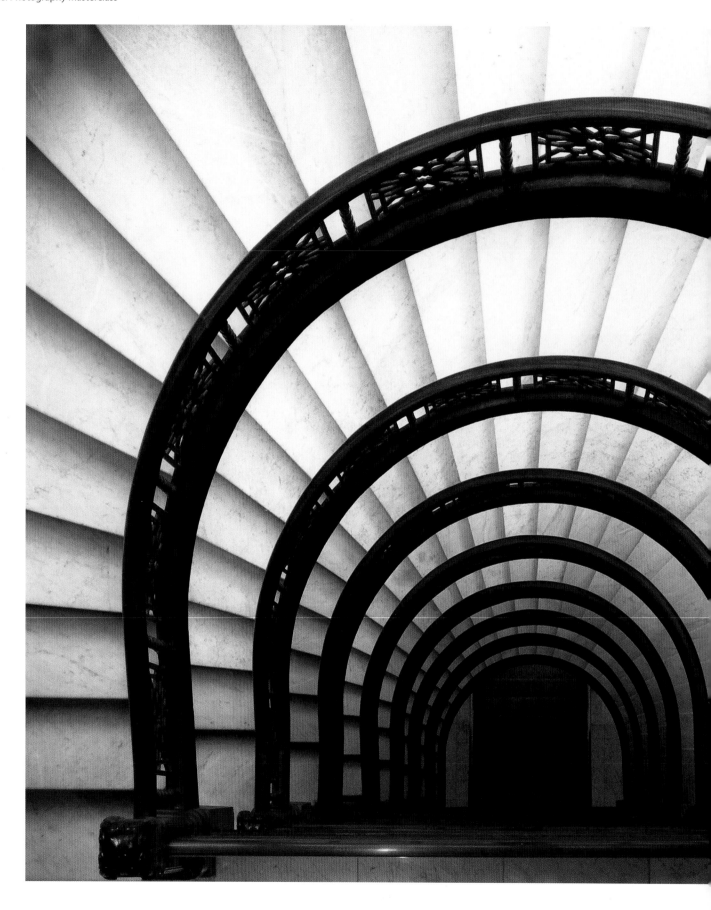

The Rookery, Chicago, USA | Charlie Waite

The Rookery is the oldest high-rise building in Chicago that's still standing. This view of its staircase creates an optical illusion, in that it's difficult to tell whether you're looking up or down. It can even look like a very elaborate subway. There are no reference points other than the fanning out of the stairs. I had to compose extremely carefully – not only to ensure there was no overlapping of the balustrades, but also to avoid falling over the banister when I leaned out as far as I could...

overt) that echo it; are there references to its surroundings, or is it bold in its contrast? All these factors give us indicators as to what the architect's message might be, and as photographers it's our duty to reveal these nuances and finer details, as well as the unique arrangement of shapes, textures, colours and patterns that he or she has created.

What makes an architectural photograph?
There might be playful elements within the building, such as a staircase – which provides the photographer with the perfect 'entrance' into a photograph – or a detail in a window, which asks questions about what might be going on beyond the confines of its four walls. Light, of course, plays a crucial role, too, and this can be a gift to photographers. You might be fortunate enough to find yourself in a building at a particular time of day, when the light streaming through a window interacts with the interior, giving extra depth and dimension that can breathe life into an image. When I spot little treasures such as this, I am always convinced that the architects knew exactly what they were doing when they designed the building in that particular way.

Of course, we are at liberty to interpret architecture as freely as we like. We don't have to be prescriptive in our approach. As such, a dilapidated croft set against a wild Scottish mountain is every bit as much an architectural photograph as a stark representation of a modern office building. Nor do we even have to include the structure itself. A set of railings that represent a building's boundaries not only provide a strong diagonal line within a composition – adding a sense of dynamism and tension – but also tell a story about a building's environment, even though that building might not feature in the frame.

Exploring all avenues
Creativity can be tricky to channel effectively when we know we only have limited time in a particular place, and we don't know when, or if, we will return. It is essential, therefore, to have a commitment to the image you are trying to capture. If you're a 'that'll do' kind of person, you'll never achieve the picture you really want, because you won't have explored every possibility.

Those possibilities might include working in different light, at different times of day, or breaking out of the usual restrictions of wide depth of field and fast shutter speeds. I am always obsessed with perfection, but in the past I wanted everything to be still and wouldn't stray from my own set of rules. Nowadays, however, I enjoy witnessing the effect of movement in my images – how this evokes a different response in the viewer to images in which everything is perfect and in its place. If you can convey meaning in a travel photograph in a slightly less literal way – in a way that stimulates and asks something more of the viewer – then they will be moved.

With architecture the challenge for the photographer is to bring inanimate structures to life. For me, it's about subtleties such as the interaction of light in some of the less obvious corners, or the relationship of windows to the rest of the building – be that to do with their height, their shape or the nature of their repetition within the design. It's also important to observe the way light is reflected off a building. Look at the surface and take in the extent to which it absorbs or reflects light: the contrast may not be as high as it first appears. Respond to what you see in front of you, but try to avoid the obvious and don't be afraid to reinterpret a scene – that way, your images will be your own, whether they are taken in a destination unfamiliar to most of us, or one visited by millions each year. ■

Atlanta, Georgia, USA |
Charlie Waite

This image breaks into new territory for me, in that it is a more 'pure' architectural photograph. The shades of blue – from bright to navy – are broken up by the lines, which are actually cables that are covered in creepers throughout spring and summer. I was lying underneath them, looking up at the building. The line that matters most is the one going through the top of the building, and they meet in a kind of Star of David at the bottom left. Where the building is at its smallest in the frame, the star shapes are at their smallest, too.

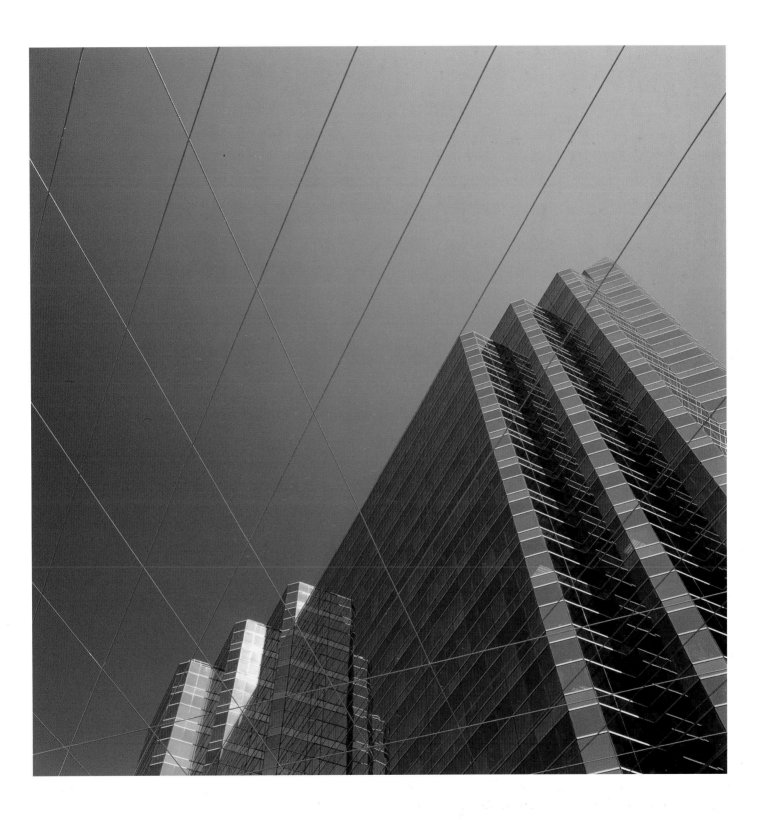

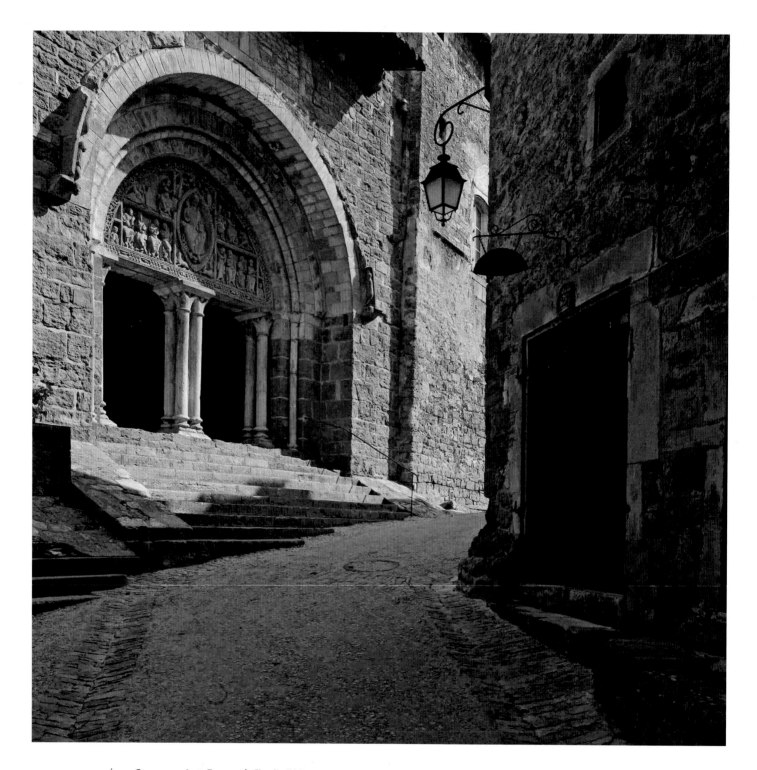

Carennac, Lot, France | Charlie Waite

About half of this image is in shadow, which is unusual, but it works because the stonework is pale and the shadows were filled in by light from an opposite wall. Thankfully, the door on the right was polished, so retained some detail. Everything in the composition sweeps up to the amazing portal and, of course, anything that takes the viewer around a corner always adds a sense of mystery.

Colmar, Alsace, France | Charlie Waite

This is rather a sad picture, of a lonely window that's been left to rot. The shutters almost look as if they've been made from the bark of the silver birch. There are three main tones: pewter, amber and a little bit of white. Someone suggested that I should clone out the white patch at the top left corner of the window, but I purposely left it there.

Observation wheel, Greenwich, London | Charlie Waite

These tents were temporary structures, used to conceal the engineering work going on underneath. I'm passionate about arcs, and I thought the wheel emerging from the tents looked impressive. I spent ages trying to make sure carriages didn't intersect with tents, and their symmetry is offset by the fantastic sky behind.

Case Study | Charlie Waite
Cienfuegos, Cuba

It took me three mornings to resolve this image – I made almost endless attempts to get it right, and was late for breakfast every day because of it. The sky, the sun and the shadows were always wrong somehow, but finally it came together. The recurring triangles were the first features I noticed, and I wanted to make an image where they worked together. All the lines appear to rush towards the farthest point, where they join up at a little triangular shadow that intersects with the distant hill, and it's this that binds the picture. The whole thing is glamourised by the red fire extinguishers and reflection on the floor. And although someone did once tell me

it was a 'shame' about the extinguishers, I don't believe the image would work without them. The wall on the left is very important, too, because although the rest of the photograph is essentially about blue and yellow, the wall features a touch of magenta at the far end, which echoes the fire extinguishers. This photograph is very much a lesson in perseverance, and shows how valuable it is to have a compact camera on you at all times – because otherwise how would we capitalise on these little surprises? I also enjoy the fact that it's a rather mysterious picture. People have trouble working out where and what it is. It just 'hangs' there somehow.

CHAPTER 4 : **WILDLIFE**

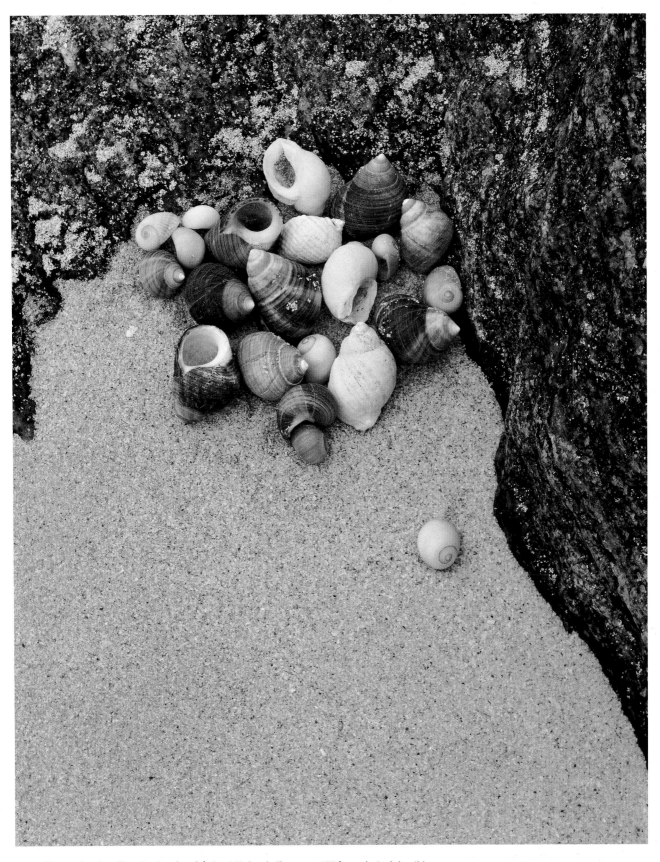

Bostadh Beach, Isle of Lewis, Scotland | Sami Nabeel *(See page 157 for technical details)*

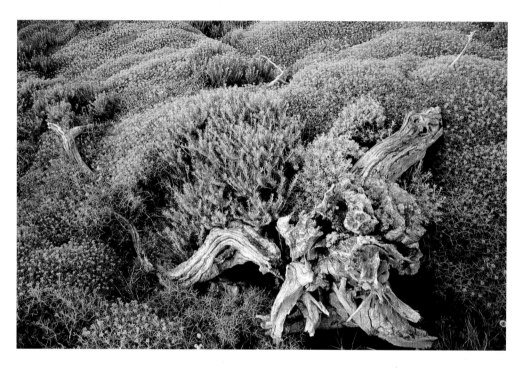

Fallen log, Chile | Anna Booth
(See page 157 for technical details)

Introduction

Passion, tenacity and patience are all qualities that the nature and wildlife photographer must possess in abundance. It could be argued that no other genre of photography presents such extremes: the frustration you feel when the creature you've been stalking for days just doesn't show up, and the satisfaction that comes when all your hard work and forbearance is finally paid off with a picture that perfectly captures the animal in its environment.

Many photographers experience their first introduction to wildlife photography through safaris that guarantee viewings of the 'big five' – that is, the lion, the African elephant, the Cape buffalo, the leopard and the black rhinoceros. These can be great ways to hone one's long-lens technique, and the satisfaction of being in close proximity to such extraordinary creatures cannot be overestimated. However, it is easy in such circumstances to overlook the less spectacular subjects – and yet these can convey stories that are just as fascinating. A tiny flower pushing through a snow-covered mountain speaks of survival in the harshest conditions, and of new life, while a humble toad hiding in the undergrowth – although not beautiful in the conventional sense – might be as endangered as a mighty tiger. **AMc**

BEN OSBORNE

Celebrating the natural world

Travel, for me, begins when I walk out of my front door. I even consider walking my dog to be travel. As a photographer, you absorb yourself in your surroundings the moment you leave your home, so pretty much anything falls into this category. However, if you are going away from home to take photographs – somewhere away from your immediate environment – then your travelling begins when you are actually at your destination or location, and not when you're on the flight or going through customs. So, in that sense, travel is about being somewhere rather than going somewhere. It's a subtle but important distinction.

And it might sound strange, but the *experience* of travel always comes first. The photography takes second place. But that experience allows you to get under the skin of a place – which, in turn, should give your photographs greater depth. This philosophy comes from my background as a biologist. I was always interested in animals first – it was my discovery of photography that gave me a medium with which to express that interest. As such, my work is all geared towards celebrating the natural world, sharing it, and being inspired by it. In the end it's not necessarily about photography, but about the importance of animals and a love of wild places.

Creating a portfolio

When I travel, it's often with a commission to photograph a particular species or environment, or to accompany a film crew. This means I don't always shoot pure wildlife – I might have to take a more general approach, or photograph the crews themselves, too. While, to some, it might feel that documenting the workings of the team detracts from the 'purer' wildlife photography intentions, film crews have to work in a very specific way in order to tell a story about what it is they're filming, and as a photographer you can learn a great deal from that. One still image alone can be strong, but a set of five reveals much more. The result might be a portfolio that is more than the sum of its parts. As such, you will want to take an individual animal or species, and say something in pictures about its lifestyle: where it lives, what it feeds on, how it survives, and so on.

You can't achieve this, however, without knowing your subject. Fundamental to successful wildlife images is the need to understand the behaviour of the creature you are photographing. If you know why it's behaving in a particular way, then you know why you're photographing it, and your images will be more powerful as a result. I always say that this process should begin in our own backyards. It also improves your photography, because working at home allows you to hone your technique. It will be second nature when you embark on a major trip overseas.

One of the most satisfying things about travelling in order to make wildlife photographs is that it reminds us of our place in the natural world. As a species, this is something we have lost sight of, and I find there is a deep satisfaction – a joy, even – in using photography as an excuse to simply get out and watch animals more. Inevitably, these observations bring to the fore the issues surrounding the environment, →

Penguins, St Andrew's Bay, South Georgia | Ben Osborne

One of my best-known and favourite images, this was used on the cover of the BBC's Life in the Freezer *book. I worked hard for it. The behaviour is part of the king penguins' courtship display, and normally takes place in the middle of the colony so the background is chaotic. I needed to find a pair on the edge of the colony and then keep my lens trained on them and not allow myself to be distracted by the other penguins. It was an exercise in seeing that something is about to happen and sticking with it.*

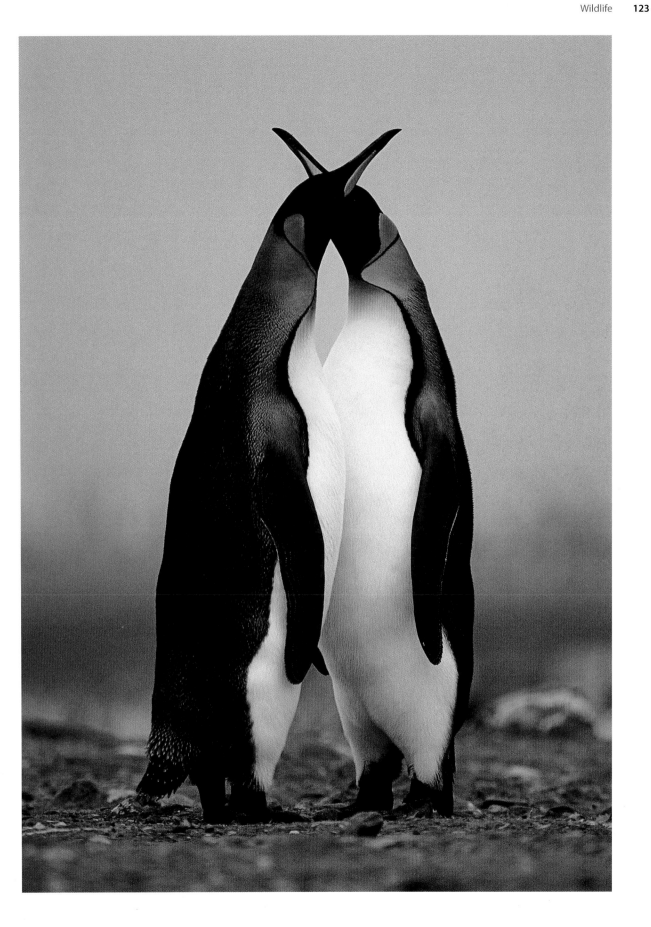

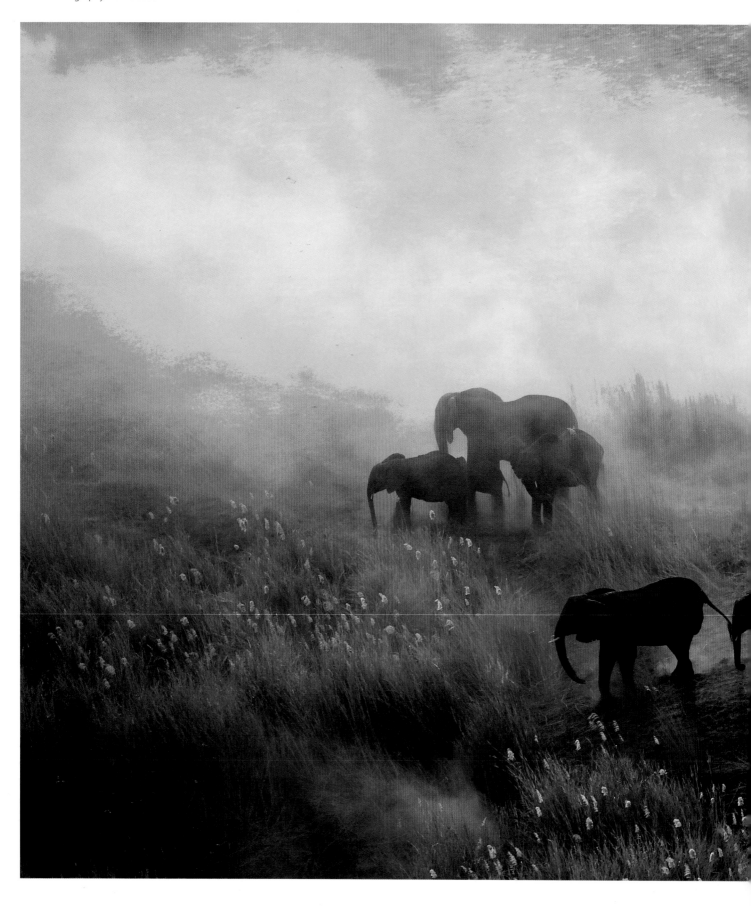

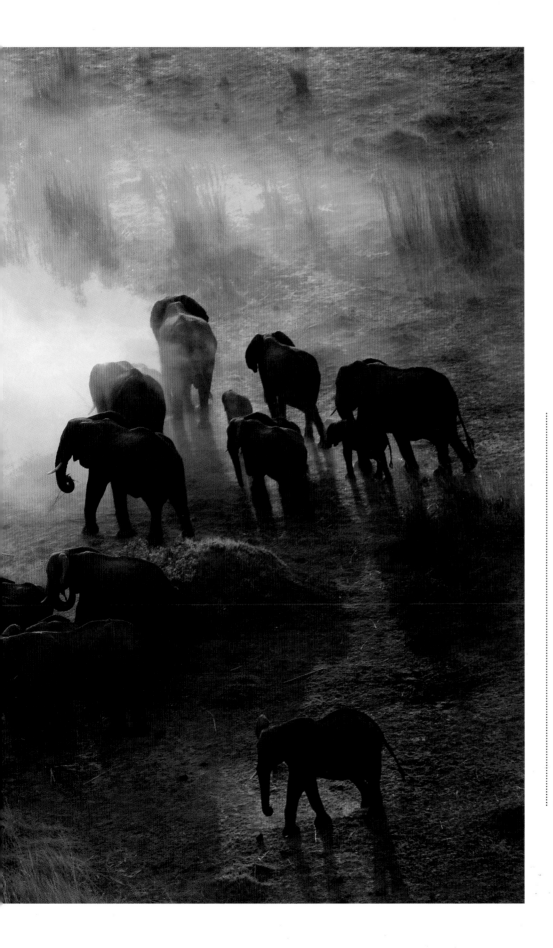

Elephants, northern
Botswana |
Ben Osborne

*I had been
commissioned by the
BBC to produce some
images to accompany
the* Planet Earth *series.
The aim of one of the
stories was to show how
elephants survive in dry
conditions, and how
far they have to travel
for water. We went up
in a helicopter at dawn
and dusk, when the
light is at its best, and
I shot with a long lens
so we could remain far
enough away so as not
to disturb the animals.
An image-stabilisation
lens was essential!*

global warming, pollution, deforestation… any number of similar concerns. With photography we can tell stories about these subjects in any way we choose.

However we choose to tell a story, or portray a species, there's no way that story will succeed unless we ourselves slow down. I always advise that we should spend less time moving and more time watching. In wildlife photography that's essential. In 2007 I won the Wildlife Photographer of the Year competition with a close-up image of an elephant at a waterhole. The photograph was taken during a one-month period I spent in a single location in northern Botswana. I got to know this space intimately. Every morning and every evening I visited the waterhole, so I learned the time the elephants would arrive, how they interacted, the impact of the light on any photographs – and the surrounding area. This waterhole was only 40 feet across, but I saw something different every day, partly because I varied my position and distance from it, so I could be right next to the elephant trail one day, or far from it the next. While I accept that people will be keen to visit a variety of locations, I would suggest going to, say, three different locations rather than eight in two weeks. It's always better to stay than simply to pass through.

Equipping yourself

As with any genre of photography, there are certain considerations in terms of equipment that will make your life easier – thus freeing you up to concentrate on making images. It's rare to meet a wildlife photographer who hasn't embraced digital wholeheartedly, and two DSLR bodies are usually preferable to one, as it's always a good idea to have a back-up, particularly if you're visiting a tough environment where something might go wrong and be difficult to fix. Always have a wide-angle lens and a telephoto zoom of around the 70–300mm range, and the faster the autofocus the better, as timing is always critical in wildlife photography.

Wildlife photographers have a tendency to create large numbers of images very quickly – much more so than landscape – so you need to have a system in place that allows you to download images quickly and recycle the cards to be filled with fresh photographs. I have a very lightweight laptop, and plug in two external hard drives as I never wipe a memory card until the images have been backed up in at least two places. Of course, this raises issues about power, so always have plenty of spare batteries.

Beyond photography

When you have built up a body of work on a particular subject, it can be interesting to take it one step further. Photography is a great way of describing a place or a particular species, but your images can be complemented beautifully with sounds. Take a small digital recorder with you and record the sounds in the area you are working in. When you return home and play them back you'll realise just how evocative they are. You might like to use these – perhaps along with recordings of local music – to create a slideshow about your experiences. The images are central, but sound will add another dimension, taking you beyond photography alone.

Travel gives the photographer an ever-changing outlook on life and, more specifically, as a wildlife photographer, it helps you appreciate the natural world. From the physical to the spiritual aspect of it – or wherever you want to sit between those two philosophies – it's important to appreciate what it means to us. Above all, don't regard wildlife photography as a process of working through a 'tick list'. It's about understanding and living with it – and just being there. ∎

Don't take risks just for a photograph

Take your personal safety seriously, especially around dangerous animals. People can sometimes behave stupidly just to get a picture, but it's not worth the risk.

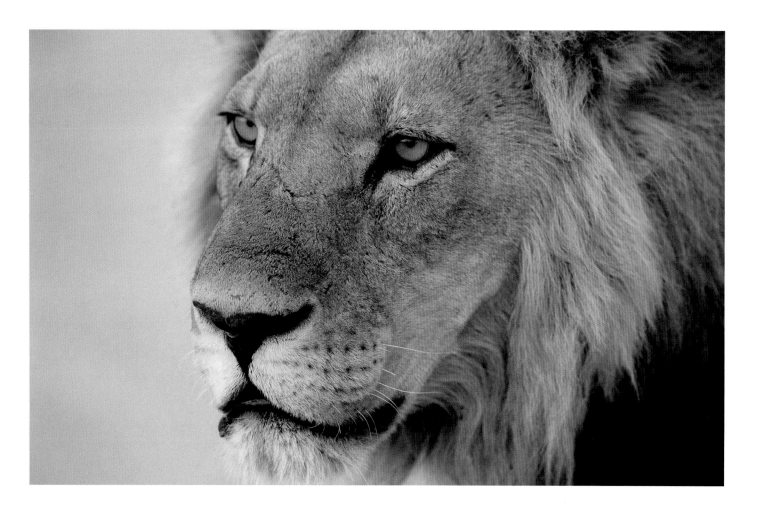

Male lion, Chobe National Park, Botswana | Ben Osborne

This lion was from a pride which, unusually, had hunted in daylight. The hunt was unsuccessful and they were pretty hungry, so this male was prowling around looking rather mean. I was photographing them passing our vehicle, which had an open back. I suddenly realised he was really big in the viewfinder, so I popped my head up and saw just how close he was! I had to have faith in the fact that lions don't take people from vehicles, but it did bring home just how impressive these animals are.

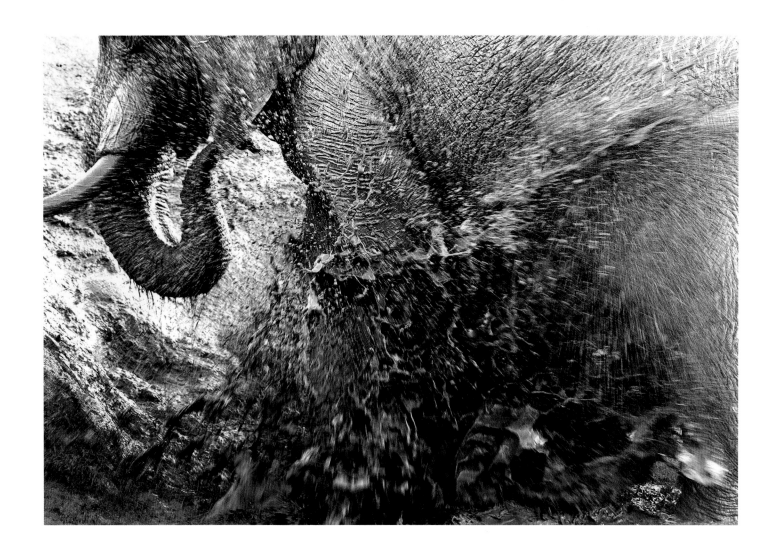

Elephant, Favuti, Chobe National Park, Botswana | Ben Osborne

When a waterhole overflowed into a nearby shallow area, it pooled, and created a mud bath where the elephants came to bathe. I didn't manage to capture this behaviour first time around, but when it overflowed again I was ready. I parked my vehicle so that it was looking down into the wallow, and photographed from the vehicle. A big bull elephant began kicking with its feet, and squirting with its trunk, and I wanted to capture the energy, movement and dynamism of the behaviour. As it was late evening the light was low, so a wide aperture and long-ish shutter speed meant the result was quite soft. But enough was in focus to make it work. The picture won the Wildlife Photographer of the Year award in 2007.

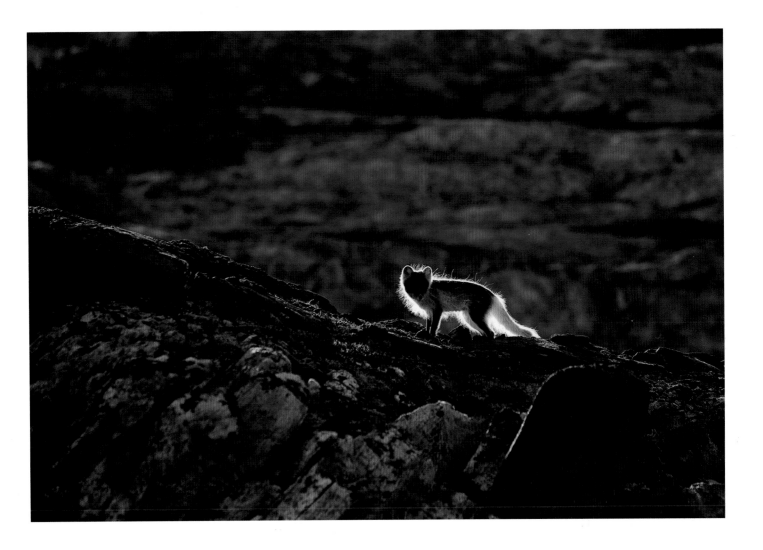

Arctic fox, Greenland | Ben Osborne

I was in Greenland to photograph the landscape, but a couple of Arctic foxes found our camp quite quickly. They are foraging, opportunist feeders, so I imagine when they smelled our food they thought it would make a change from scavenging along the seashore. This one came right into the camp, peed on my jacket, and then wandered back onto the rocks above, where it caught the sunlight.

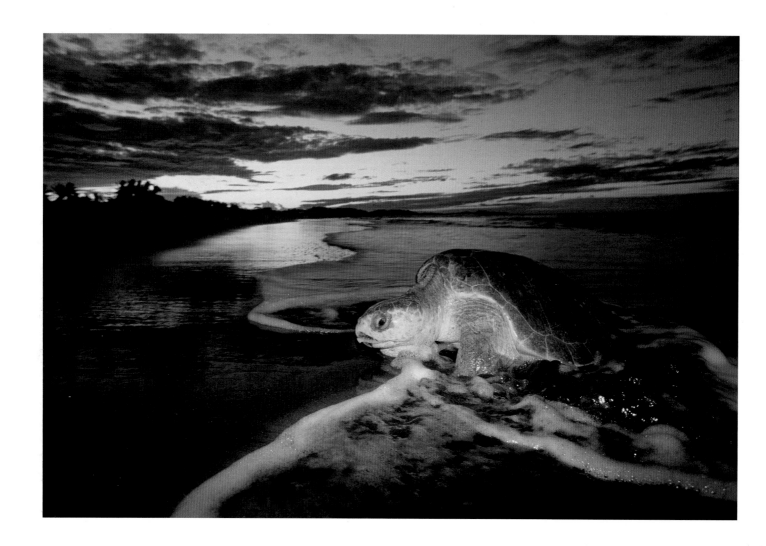

Olive Ridley turtle, Costa Rica | Ben Osborne

I was with a film crew working on the BBC series The Blue Planet, *and we were filming turtles coming ashore to breed. Tens of thousands of them come ashore once a month – and this was one of the last few that arrived that night. You can see the dawn light breaking in the distance, and this meant I could use flash, which isn't permitted when it's dark.*

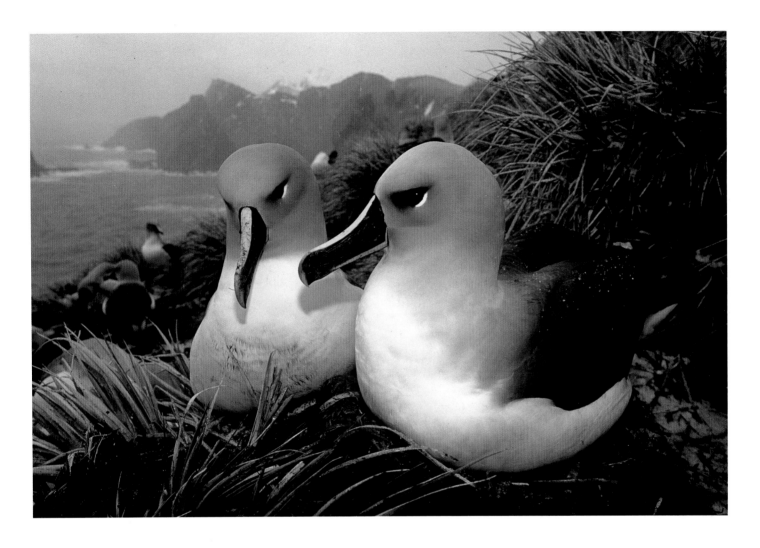

Case Study | Ben Osborne

Pair of albatrosses, South Georgia

This is a study of my favourite bird, the albatross, in my favourite place – the island of South Georgia, in the sub-Antarctic region. It's unbelievably wild there, and even though it was early in the breeding season – late September – when this photograph was taken, the weather was still pretty bad. I was about 150m up a cliff, the waves below were enormous, and it was snowing – as can be seen from the flakes on the birds' backs. The birds in the picture are grey-headed albatross and, of the four species present on South Georgia, I find these the most beautiful. They had just begun their breeding cycle so were going through their courtship displays and building their nests, which would have been destroyed by the winter weather –

hence the mud on their beaks. By using a wide-angle lens I was able to impart a sense of space and place, and to show the harsh environment. Because it was early in the season the light was still low, so I used fill flash to brighten the birds' plumage. It has created a shadow on their chests from their beaks, but it highlighted the detail on their faces. It took a while for me to capture an image where the birds were in a pleasing position. Working without disturbing them, and ensuring the background was clean, were both important factors in the image's success. One final useful point is that the top of the grey-headed albatross is nature's perfect grey card, as it's almost exactly 18 per cent grey!

WILDLIFE GALLERY

Coquelicots | Claire Davey

Be alert at all times

Keep half an eye open for other things that are going on around you. You never quite know what's going to happen.

p133 Coquelicots
Cénevières, Lot, France

Claire Davey

p135 Inquisitive Mr Arctic Fox
East Greenland

Christopher Bowman

p133

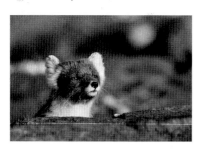

p135

Inspiration: I love poppies and so was in my element in this particular field. I also love detail and with the volume of flowers I had plenty to choose from. I'd made several images with a longer shutter speed to capture movement. Having just learnt about multiple exposures I changed tack and applied this method in order to experiment.
The situation: Poppies as far as the eye could see. I couldn't see a way of making a big picture of them *en masse* so I tried to pick out a few for a close-up. There was a breeze so I opted for a multiple exposure with three shots, but maintained the position of the camera, which was on a tripod.
Camerawork: Nikon D700 with Nikkor VR 18–200mm lens at 150mm, ISO 200, 1/400 sec at f/5.6.

On reflection: *The combination of red and green is vibrant yet the softness achieved from the multiple exposure gives the image a dreamy atmosphere. However, the poppies remain distinct. I should have watched out for the poppy in the background, which is distracting as it's sharper than the others.*

Inspiration: An arctic fox is inspirational in itself, as is all 'life in the freezer' – even in summertime. An opportunity such as this is rare indeed.
The situation: When the fox turned up in our campsite one evening, it was as close to armchair photography as you can get. He was completely unfazed by our attention, and took his time exploring the vicinity – and leaving his calling card.
Camerawork: Canon EOS 30D with Canon EF 100–400mm f/5.6 L IS USM lens, ISO 400, 1/1600 sec at f/5.6.
Post capture: This was limited to cropping, slight sharpening and adjustments in Curves.

On reflection: *It would have helped if I had either been closer or used the telephoto at its full extent to minimise the amount of cropping at the post-capture stage.*

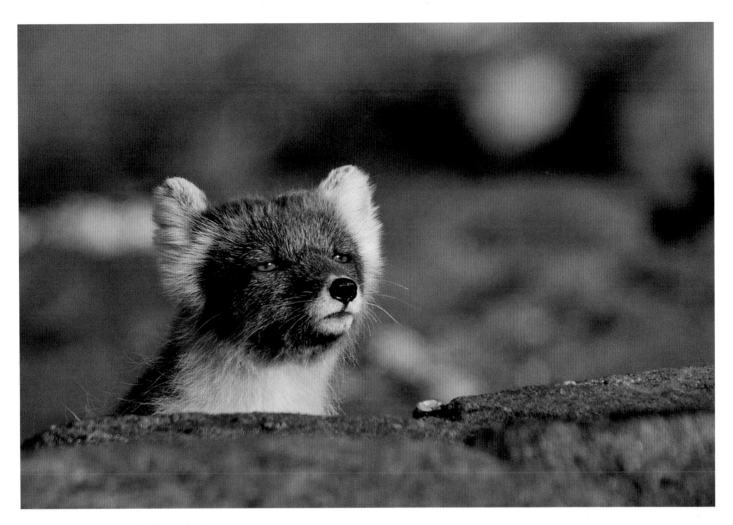

Inquisitive Mr Arctic Fox | Christopher Bowman

Choose your distance with care

Leaving space around the subject you are photographing can have just as much impact as a close-up. Wildlife doesn't have to fill the frame to be important. By leaving breathing space around the animal or plant you can place it in the environment in which it exists and tell a very different story about it.

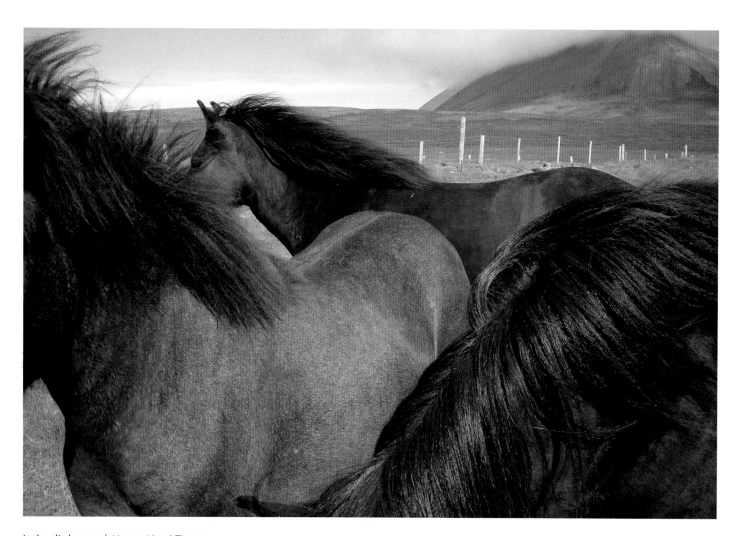

Icelandic horses | Harvey Lloyd-Thomas

The sum of the parts

Detail shots are just as pertinent to wildlife photography as they are to any other genre. Think about using longer lenses to isolate a particular characteristic of an animal – be it the harlequin-like pattern in a giraffe's coat, the keen eye of a leopard or a majestic stag's antlers.

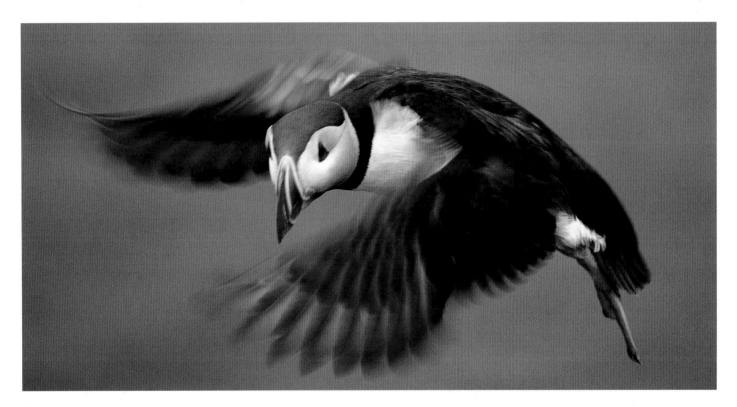

Puffin at Làtrabjarg | Phil Staff

Poor-weather pictures

Sometimes appalling weather can tell a story of its own. The likes of snow, wind and rain can provide some of the most exciting conditions for photography. Protect your lenses with a cover of some kind – even a plastic bag will do – and ensure you are clothed properly for photographing in extreme conditions.

Wheat ears | Claire Davey

Salt marsh, Isle of Lewis, Scotland | Jane C Goodall

Look for pictures that tell a story

Many different themes can be studied in a single place. You might want to make a series of images from dawn to dusk, or work over a longer period of time, showing how the seasons influence a region's wildlife. It's also fascinating to study the lifecycle of a single breed of animal, its courtship rituals or how it hunts.

Approach your subject with imagination

Not all images need to be pin sharp. Experiment with longer shutter speeds and panning, instead of increasing the ISO and opening up to your widest aperture.

p136 Icelandic horses
Skagi Peninsula, Iceland
Harvey Lloyd-Thomas

p137 Puffin at Làtrabjarg
Làtrabjarg, northwest Iceland
Phil Staff

p136

p137

Inspiration: I'd stopped earlier to try to photograph some horses, but a local dog had scared them off. However, further down the road was another field of horses who were inquisitive and happy to pose. I chose to capture the image in black and white, having been inspired by the work of Icelandic photographer Ragnar Axelsson.

The situation: There was an element of luck in getting this shot, since the autofocus in my camera was somewhat sluggish and I was only able to roughly compose as the horses trotted past. Most of my other photographs from this sequence do include the full horses' heads, but I like the abstract aspect of this image and the balance of shapes and tones.

Camerawork: Nikon COOLPIX P5000 with Zoom-Nikkor 7.5–26.3mm f/2.7-5.3 at 7.5mm, ISO 64, 1/1000 sec at f/2.7, in-camera black-and-white mode with simulated red filter.

On reflection: *Using a camera with better autofocus would have meant there was less chance involved, but then again the chance element is one of the reasons I like the image. Also I don't believe the picture would be as strong without the fence posts in the distance, which I didn't have time to notice when I pressed the shutter.*

Inspiration: I had been walking around the cliff tops capturing static images of the puffins, singly and in pairs, but was after a more dynamic, action shot. After watching for a few minutes I realised they seemed to be simply launching themselves off the cliffs, flying down to sea level then immediately returning to the cliff tops. I decided I could track a single bird and that there was a chance to get an image when it flew back to land.

The situation: I was crouching close to the edge of the cliff so I could track the puffin's flight, but my efforts to capture it large in the frame were hampered by a light drizzle and a blustery wind. I increased the ISO to 200 to obtain a faster shutter speed and then experimented with different zoom lengths until I captured this shot.

Camerawork: Nikon D70 with 70–300mm lens at 220mm, ISO 200, 1/160 sec at f/5.3.

Post capture: I used RawShooter to brighten the image; subsequently I used Photoshop to clone out some sensor marks and to crop the final picture.

On reflection: *While this image was made by tracking a single puffin, I would have liked to include the cliff top.*

Something new under the sun

Instead of photographing everything you see, concentrate on achieving several difficult, time-consuming images you've never seen before. It's much more satisfying.

p138 **Wheat ears**
Martel, Dordogne, France

Claire Davey

p139 **Salt marsh**
Isle of Lewis, Scotland

Jane C Goodall

p139

p138

Inspiration: I enjoy macro photography and was able to try all sorts of possibilities in this field of wheat. I was inspired by the lines and symmetry of the wheat ears and tried to pick out a near perfect example. I wanted to fill the frame and as it wasn't possible to find three identical wheat ears next to each other I chose to use multiple exposure.

The situation: A fellow traveller had spotted a wheat field and although I wasn't inspired I nevertheless got out of the bus. After a closer look a macro view of the wheat ears with the soft late afternoon light seemed possible. I went in very close to get as much detail as possible with a small depth of field to soften any other detail. I then decided to try the multiple exposure route, with three shots, moving the camera and positioning the wheat ears differently for each one.

Camerawork: Nikon D700 with Nikkor 105mm macro lens, ISO 200, 1/800 sec at f/3.5.

On reflection: *The multiple exposure worked well because I managed to position the wheat ears nearly symmetrically. The slight breeze and the fact that the image was handheld resulted in a pleasing effect of softness. The blurred-out wheat at the bottom could have been avoided by reframing the image.*

Inspiration: The simplicity of the subject was the most compelling feature of the scene. I liked the delicacy of the reeds in the large dark space of the salt marsh. The inky blackness of the water provided a wonderful backdrop to the vivid green of the reeds. I was also struck by the reflections from the reed bed, which danced along the water's surface.

The situation: Getting the framing of the composition right took a bit of fiddling around with the tripod to avoid including any distracting elements such as the reed bed in the upper right. I wanted to look down onto the scene so the reeds were set against the water rather than the bank and reed bed. The height of the tripod was crucial to capturing the subtle reflections of the clouds. I wanted the reed reflections to be as discernible as the reeds themselves, but the wind kept disrupting the water's surface, so I had to wait for moments between gusts to capture the image.

Camerawork: Canon EOS 5D with Canon 24–105mm lens, ISO 320, f/6.3.

Post capture: Using Photoshop CS2, I made some basic adjustments layers to enable the darkness of the water to be realized from the RAW files. The clone tool was useful for removing any distracting seed heads that were floating on the water's surface.

On reflection: *I find simple but visually compelling images very difficult to make. Finding a small scene to focus on allowed me to spend time on working with the few elements in the composition. I hope that the image is not too static and the haunting reflections of the reed bed impart a feeling of movement to the composition.*

Sant'Antimo churchyard poppy | David O'Brien

Check all details

If it's impossible or inappropriate to have a completely plain background, look for colours, shapes and features that complement your main subject.

p142 **Sant'Antimo churchyard poppy**
Tuscany, Italy
David O'Brien

Top Tips

p142

Inspiration: The famous Abbazia di Sant'Antimo and the surrounding countryside have much to offer the photographer, but while strolling around the churchyard in the early afternoon, I was drawn to this aged tree trunk and the abundance of plants at its base. The subtle delicacy of the borage, with its muted green colour and light blue flowers complemented the grey/black trunk perfectly. The single poppy – a splash of red – was the icing on the cake.

The situation: Although setting up the image was straightforward, I thought it would work best with low contrast so I had to wait for the sun to hide behind one of the large clouds moving slowly across the sky. I wanted to emphasise the delicate feather-like bristles on the plant stems, so chose an aperture that would throw the tree trunk slightly out of focus. It was the colour of the trunk that was important to me, not the texture; the plant and the poppy were to take centre stage.

Camerawork: Canon EOS 20D with Canon EF 28–135mm lens at 49mm, ISO 100, 1/200 sec at f/5.6, tripod.

Post capture: Using Adobe Lightroom only, I made minor tweaks to the contrast and saturation levels, enough to bring life to the RAW file.

On reflection: *Although pleased with the final image, I have occasionally considered whether my choice of aperture was correct. By choosing a larger aperture, I may have succeeded in throwing the tree trunk slightly out of focus, but the resulting shallow depth of field has made some of the plant stems near the trunk slightly soft.*

1. Buy lenses that incorporate image-stabilising technology, and always carry more than one, in case of disaster.

2. Use fast memory cards, but don't buy huge ones. If you lose or damage one of three or four 8GB cards, it's frustrating, but better than risking everything on one 32GB card.

3. If you're going to spend a lot of money on your first wildlife photography trip, go somewhere with good access to animals – then go somewhere trickier next time.

4. Always use local knowledge and local guides. They'll spot things you've never even considered.

5. Respect animals at all times. Don't impose on any creature, or do something to make it behave the way you want it to, just so you can take a picture. Remember you're there purely as an observer. **BO**

NIALL BENVIE
Travel photography with a difference

My reasons for travelling are a bit different to those of many other photographers. For my wildlife photography, I like to travel to places where I can photograph species that we have here in Scotland but which are either more abundant or easier to photograph abroad. It might also be the case that certain species don't feature the same restrictions on photographing them in other countries as they do in the UK. This is the reason I first travelled to the Baltic States in the 1990s, and, after over 20 trips to Latvia and Estonia it's an area that I've become familiar with over the years.

I'm particularly interested in northern European species, such as the sea eagle and black-throated diver, and mammals like the beaver. Even quite common species like ravens are much easier to photograph in certain countries abroad. Amphibians, for example, are abundant in Lativa and Estonia and I can be much more productive working there than staying in Scotland, shooting more variety in a couple of weeks there than I could in a couple of seasons in Scotland.

The other main reason to travel is the weather. Snowfall is still quite reliable in Estonia and Finland – unlike Scotland and even my old haunts in Norway. I just love the simplicity of a snow-covered landscape and it is a great setting for wildlife pictures.

Local knowledge

Much of my photography is project-orientated. The only time I might consider going somewhere 'blind', is if I have contacts in that country who can help guide and advise me. A trip to Finland in winter 2009, for example, happened only because I travelled with some Estonian friends who had been there before and could speak some Finnish. I wanted to do this trip to gather some material for a little project I'm calling 'Nostalgia for Snow'. In it, I ask the viewer to imagine it's 30 years hence and they are reflecting on the losses – cultural as well as in terms of wildlife and habitats – that have happened over that time. Of course, the pictures are shot today but given a retro. treatment to make them look like they are old. This way, people are being asked to think now about how they will feel if the current warming trend continues and, perhaps, may be galvanized to speak up about the issue.

I have to be quite realistic about the financial aspect of overseas trips. I can't travel in luxury, or stay in expensive hotels because it would make any pictures I took uneconomical. As such, I've always relied on the kindness of strangers, often someone who's seen my work, written to me and invited me to photograph their country. I usually say yes, and have made some very good friends as a result. But I can't spend a lot of money just hoping that I might achieve some successful pictures. It's usually a long time before a trip can even wash its face, let alone make me a profit.

The expressive picture

My photography is driven by passion – and that goes for the overseas work too. If I am working a relatively unknown area, I need pictures that show what it looks like →

Kingfisher |
Niall Benvie

I had been invited to Israel by the country's leading wildlife photographer, Yossi Eshbol, to give a talk. An enormous variety of birds can be found on the saltpans near his home in northern Israel, to the extent that even this kingfisher could be photographed using the car as a hide.

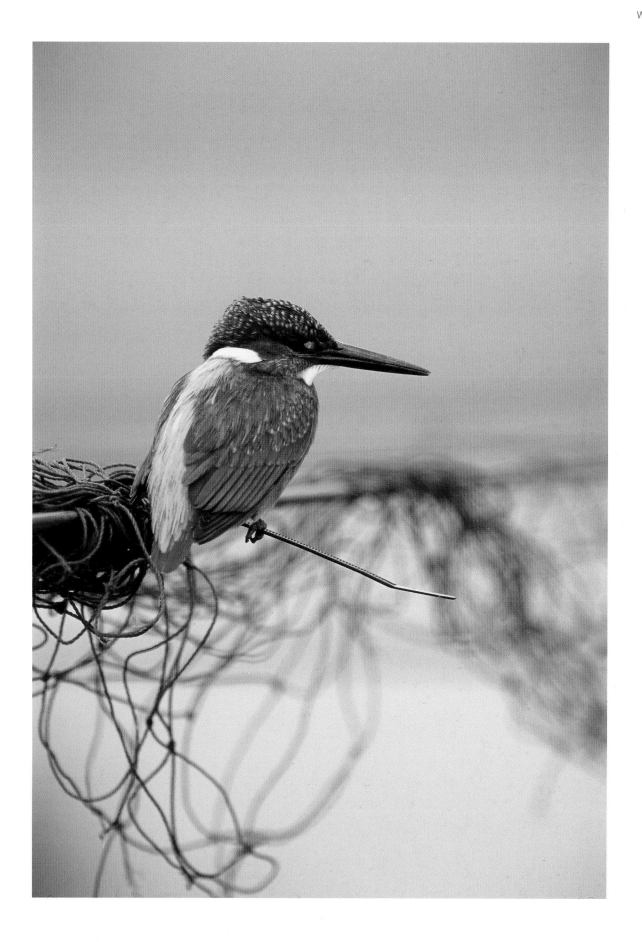

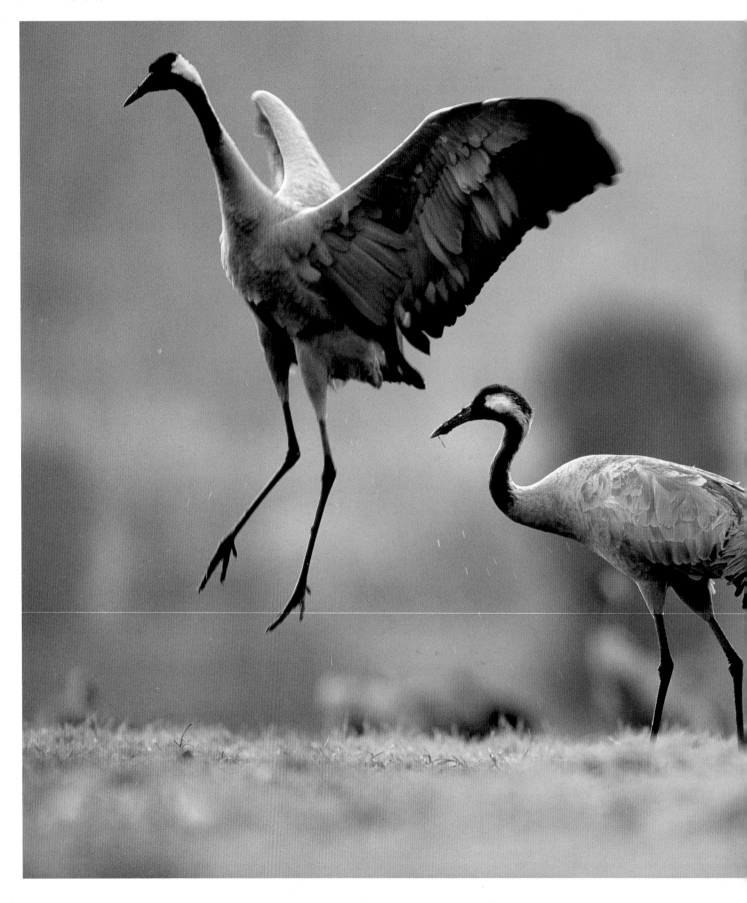

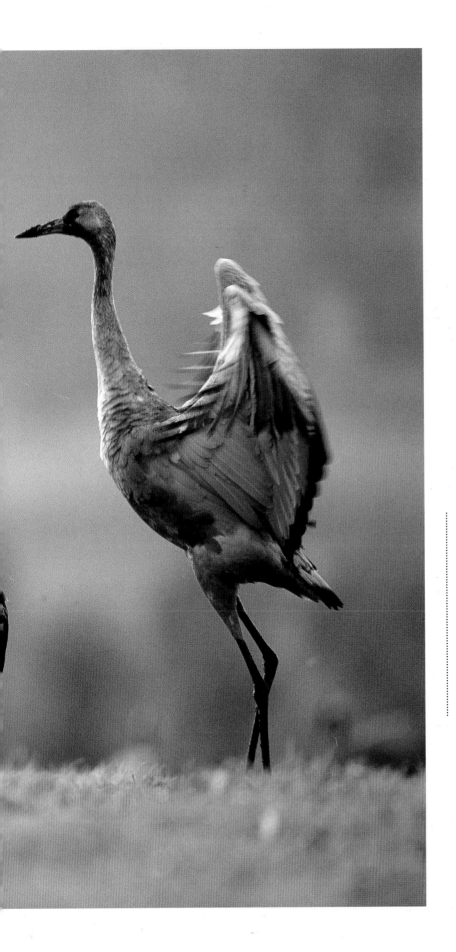

Cranes | Niall Benvie

Every year tens of thousands of cranes migrate from northern and eastern Europe, to spend winter in this valley in northern Israel. When they first started appearing in the 1950s there was a conflict with the local farmers, as the birds ate their crops, but there is now a big field dedicated to the cranes. Tons of maize are scattered in the field to keep them away from the crops, and my friend Yossi Eshbol has special permission to have a hide there. I photographed from this hide for about ten hours, but it was never boring as there was so much going on.

first and foremost. After a few trips, though, my emphasis will change from expressive images – that describe what the place looks like and what I feel about it – to narrative ones, where the primary intention is to tell a story with the pictures. I think that when most of us travel, we focus almost exclusively on the expressive image – something that is all about light, form colour and composition – without providing the subject with the context that the narrative image does. There's nothing wrong with this, of course, but it is disingenuous – and impractical – to make an expressive picture, only to ascribe it a narrative role afterwards.

The techniques and emphases we use and place are quite different for the two forms of expression; after all, painting an onion red then calling it an apple doesn't change the fact it is still an onion. I have a variety of techniques I use to remain productive – and in which I 'switch' to working expressively. Black and white is often appropriate if sympathetic to the content of the picture and the light is awful. Nocturnal light painting with a powerful torch works well to pick out certain elements in the landscape. I used this technique in Riisitunturi National Park, Finland, when it was minus 20 degrees. I think that few other photographers have tackled this well known location in this way. And with my field studio, I can shoot subjects whatever the weather – unless it's pouring with rain.

The field studio

I have used a variety of field studio for three years now, inspired by the work of photographers Susan Middleton and David Liittschwager in documenting endangered species. Their inspiration came in turn from Richard Avedon, who they assisted in the mid 1980s in New York. He had realised in the late 1940s the power of portraits shot on simple white backgrounds and my predecessors wanted to do the same with animal and plant subjects. It is a very simple set-up, comprising a backdrop of a sheet of opaque white Perspex and two very basic flashlights. Both the flashlights and the Perspex are clamped onto the arms of two old tripods. The result means my subjects – usually plants, amphibians, reptiles or invertebrates – are represented against backlit, pure white backgrounds. This shows them in extraordinary detail and, although they look like they are shot in a studio, all the pictures are made in the field. If I had to give the reader advice it would be to be clear about your objective and approach before you leave home but be open to other possibilities when you are there.

Make your pictures your own

However you choose to photograph a wildlife subject, you need to have some sort of relationship with it. I'm not attracted to 'nature photography brothels' – those well-known locations where you pay your money to photograph, for example, ospreys or bears, and as a result have a very similar photographic experience to hundreds of others before you. The reason for this is they lack any element of exclusivity. If I want to tell my story, I can't do that with a picture that looks like everybody else's. That's not to condemn those who perhaps only have a couple of weeks each year to devote themselves to their photography, but from a professional perspective, these 'bought' experiences don't work any more. If you use the other 48 weekends of the year to establish contacts overseas – via online forums for example – you'll discover that unique experiences are open to you as well. ∎

Musk ox | Niall Benvie

Dovrefjell National Park is home to the main population of musk ox in Europe. I was working with biologist Dr Duncan Halley – a Scotsman who now lives in Norway – who knew where to go to photograph the musk ox. We had to cross-country ski to get there, and then make our way up to an exposed ridge where strong winds blow the snow off the vegetation, allowing the ox to feed. Driven on by grim determination, I nearly didn't make it back, as I started to get hypothermia. Fortunately Duncan is experienced enough to recognise the symptoms and was able to get me home safely!

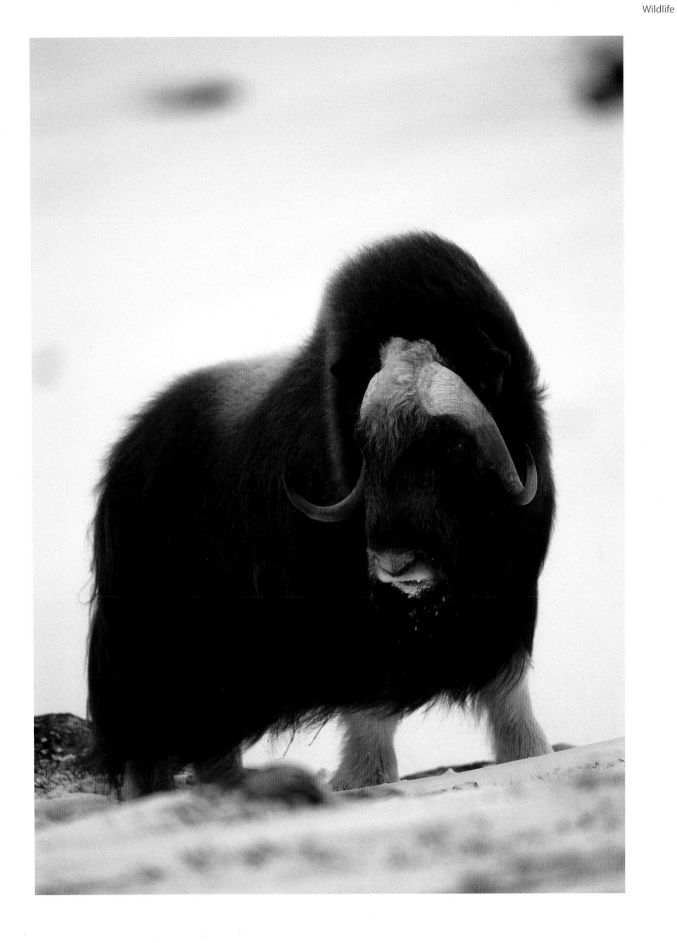

ABOVE: **Wild boar** | Niall Benvie

This is a semi-tame creature, which had been raised by Ales Toman from a piglet. I had seen boar in the wild in Poland and the Czech Republic, but they were extremely difficult to get close to. I felt that such a dynamic, lively animal deserved the blurred treatment as it ran round the property.

LEFT: **Smooth newt** | Niall Benvie

Because Estonia has relatively low levels of pollution from agricultural run-off, it has a very big amphibian population. I set up my portable studio beside a pond, caught this newt and photographed it for ten minutes before replacing it in the pond. With an approach like this it's possible to show a great deal of detail, and the resulting image is almost like a biological drawing. The skill is in waiting for the moment when the creature's gesture or pose is particularly elegant.

Cranes | Niall Benvie

Owing to the position of this hide, I needed to enter it well before dawn and the arrival of the first cranes from nearby Lake Agmon, in northern Israel. Departure couldn't come until darkness had fallen again, 11½ hours later. From the dark space of the hide, I was especially absorbed by their 'music'. This bore no resemblance to the brassy, atonal duets I have often heard from the depths of an Estonian bog; it was an altogether more bewildering cacophony at close range. So diverse was the range of sounds, that at different times I was sure I could hear bitterns, guillemot chicks and a didgeridoo. Mostly, though, it sounded like a goose with its neck stuck in a long plastic drainpipe…

Case Study | Niall Benvie
Raven at bait site, Estonia

An Estonian friend and fellow wildlife photographer, Jaanus Järva, had established this bait site in central Estonia a year prior to this photograph being taken. Its aim was to attract sea eagles and golden eagles, but inevitably a lot of ravens came to the site as well. They're useful birds, because they act as sentinels of what's going on around the site. If they're relaxed, no predatory birds will be in the vicinity, but if they're edgy then you know the sea eagles are probably nearby – and I like them for their inscrutability. This photograph was taken right in the middle of the day, when the light was very poor. About 20 yards from the hide was the dead trunk of a pine tree, and a number of the ravens were landing on and taking off from it.

There was so much bright light in the sky, I realised this would be a good opportunity to capture some shots of the birds in flight. When I saw the images, I realised the minimal colour didn't contribute to them in any way, so I converted them to black and white to simplify them further. As they had the feel of a pencil drawing about them, I used Photoframe 4.0 – made by OnOne software – to create a border that was sympathetic to the image, and enhanced its ethereal feeling. It certainly isn't what others might regard as being a conventional wildlife photograph, but my feeling is if you've invested in travelling to a particular place, you should take pictures anyway – even if they're not of the subject you intended to photograph.

Telling tales

Many still images raise a lot of questions, and this is a good thing. It's not always crucial to tell the whole story, because ultimately you want people to carry on being curious.

p11 A little bit of light fell on the land
Chateau Plain, Wolwedans, Namibia

Clive Aldenhoven

p12 Yosemite skyline
Yosemite National Park, California, USA

Brian Clark

p11

p12

Inspiration: I had been promised this would be a magic place. After stumbling up and over slippery sand dunes I came upon this biblical scene. There is almost no sign of human habitation and very little vegetation, so it looks and feels otherworldly. This wide plain with rocky outcrops like frozen waves was completely still.

The situation: Alas, it was overcast and raining – weather more like London than the Namibian desert. I tried several shots to capture a 'frozen' wave image but it was all rather murky. At last, my prayers were answered and a little bit of light did eventually fall on to this land: the biblical imagery got the better of me. I was pleasantly surprised it came out as it did.

Camerawork: Nikon D200 with Nikon 24–70mm ED-AFS lens at 65mm, ISO 100, 1/10sec at f/22, tripod.

Post capture: It was shot in RAW and mainly processed with Lightroom, using White Balance, Crop, Fill Light, Contrast, and Clarity; I also used PhotoKit to sharpen and reduce the haziness.

On reflection: *I wish this image had been sharper and had a greater dynamic range. The histogram looks like the Himalayas, so it's really hard to get a good print off this. I'd love to go back but how often does it rain in the desert – and how often will there be sunbeams?*

Inspiration: Yosemite in February can be a cold, bleak place and good light had been a bit elusive as we drove through the valley. As we turned a corner I spotted this scene high up on the skyline and raced to set up my gear before the mist dispersed. I was attracted to the beautiful colours and textures of the rock face and the way in which the trees stood like sentinels surrounded by mist.

The situation: I was fortunate to have the ideal lens with which to isolate the best part of the scene and positioned the gap in the rock face towards the right hand side of the frame. With the conditions wet and overcast, I added a polarising filter to boost the colour saturation of the rock face.

Camerawork: Nikon D2X with 70–200mm f/2.8 lens at 200mm, ISO 100, f/8 at 1/45 sec, aperture priority with no exposure compensation, Lee circular polarising filter.

Post capture: I converted the RAW image using Apple's Aperture software, then opened it in Photoshop CS3, where I made minor adjustments in both Levels and Curves. Both these actions helped to increase contrast and boost colour saturation. Finally, I sharpened the file using the Lightness channel in Lab Colour mode.

On reflection: *This image was very much about timing and I was fortunate to be able to include not only the mist but, crucially, the faint areas of blue sky which are just visible. I think most of the interest lies in the left of the frame and certainly the rock colour is more vibrant here. The rather dull appearance of the rocks to the right is fortunately broken up by the lines of snow.*

Conveying the message

Photographers are communicators, and as such it is their role to tell the story of their experiences through their pictures.

p47 **A Happy Trio**
Jampa Lhakhang, Bumthang, Bhutan

Duncan Locke

p48 **Riding up to La Junta**
Campo Avenutra, Cochamo Valley, Chile

Lucy Heber-Percy

p47

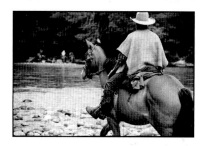

p48

Inspiration: We arrived at Jampa Lhakhang – or Jakar Dzong – in the early afternoon just before a major festival was due to start, and which we were to photograph. The young monks were in a state of great excitement and happy to have their pictures taken. The colour of their robes and their happy smiling faces contrasted well with the timeless solidity of the Dzong.

The situation: This image was the best of a number that I took of the young monks.

Camerawork: Canon G3 digital compact, 1/20 sec at f/2.2.

Post capture: There was very little post-capture work, save a small adjustment to Levels and a small amount of cropping on the right-hand side of the picture. Even in Bhutan young monks wear large shiny digital watches, which I cropped out as it didn't add to the traditional nature of the scene!

On reflection: *I much prefer taking images like this – even in poor lighting conditions –without flash as the result is a much more natural feel, richer colours and good eye contact. It has resulted in a slightly soft image.*

Inspiration: On a trip to southern Chile, I stayed in a mountain lodge in La Junta. We were on horseback, riding through the rainforest to reach the camp. I wanted to record a variety of scenes on our journey as we went and particularly the terrain we crossed over. My aim was to fill the frame with the gaucho and horse while leaving enough detail of the river that he is about to cross. I used a wide aperture to blur out the background.

The situation: As I was on horseback, close behind the gaucho, I was able to use my lens to its maximum zoom of 105mm, as I wanted to get the feeling of him coming into the frame of the picture, about to cross the river. The horse rarely stood still, so was not a good substitute for a tripod! Taking photographs from horseback was a challenge, particularly as I was not an experienced rider. I would certainly recommend lessons to anyone embarking on such a venture.

Camerawork: Canon EOS 300 with Canon EF 28–105mm f/3.5/4.5 USM MK lens, Fuji Sensia 100.

Post capture: The slide was drum-scanned to a digital file. I then increased the brightness in Photoshop using Adobe Creative Suite 4.

On reflection: *The light was a mixture – of sun with slight clouds appearing. Ideally, I would have liked to have had more light on the horse's mane, but had to go with the given light. There again, if the sun had been too strong it would probably have bleached out the texture of the poncho. I particularly like the variety of brown hues – the bay horse, gaucho's poncho and hat.*

Be selective

Travel photography is about looking, thinking and imagining. You don't always have to photograph everything that's in front of you.

p83 Sunrise behind the dome
Church of St Georgios, near Pori, Santorini, Greece

Elizabeth Restall

p84 House in the woods
Vermont, USA

Brian Whittaker

p83

p84

Inspiration: After scrambling up a grassy bank behind the church in half-light and positioning myself immediately opposite the three traffic-light-style circular windows, I hoped the first rays of sun on the horizon would illuminate them from behind. I wasn't disappointed, and fired the shutter several times at different exposures. A few minutes later the sun had climbed higher in the sky and the effect was gone.

The situation: This church is close to sea level and we travelled a long, winding downhill road to reach it before daybreak. On arrival the dome and bell tower were floodlit, but it wasn't until the lights went off and the sun began to appear that I realised the potential for some inspiring photography.

Camerawork: Canon EOS 400D with Canon 24–105mm L f/4 IS lens at 35mm, 1/160 sec at f/8.

Post capture: I carried out the post-processing in Adobe Photoshop CS4 Camera Raw. Masking preserved the correct sky exposure, while adjustments were made to lighten the building using Levels, Shadow and Highlights, Saturation, Curves and High-pass sharpening. Finally, I made a square crop to fill the frame and place emphasis on the windows.

On reflection: *It is a very dominant, central image without distractions, and works, I hope, because of this. The pale hues of the sky help to soften the overall impact.*

Inspiration: A solitary timber house overshadowed by many evergreen trees on the bend of a small lane creates an air of mystery. There is a lovely contrast between the soft grasses in the foreground and the dark trees, which provokes a question as to whether this really is a rural idyll or something a little darker. The tonal range for the evergreens against the softer background of reeds and deciduous trees makes this image work well for me.

The situation: I discovered this spot by complete luck, as the map I had didn't show all the roads I was driving on. Positioned in the long grass, I had to place the camera on the highest tripod setting to get the tops of the vegetation in shot but softly blurred, while not obscuring the house or the lane, which create the main story.

Camerawork: Canon EOS 20D with Canon 70–200mm f/2.8 at 120mm, ISO 100, 1/30 sec at f/11.

On reflection: *This was taken during a rushed 'map stop' and the grasses in the foreground are quite burnt out. I would hope to meter for this more accurately next time. I also might consider framing slightly differently, as it is quite tight on the right-hand side.*

Open to interpretation

Be on top of your subject but don't have too many preconceived ideas. Make your own interpretation of the subject you are photographing.

p119 **Bostadh Beach**
Isle of Lewis, Scotland
Sami Nabeel

p120 **Fallen log**
Chile
Anna Booth

Inspiration: I built up an image in my head of how I would like this picture to look, so it was designed rather than being a response to an existing situation.
The situation: There had been a continuous drizzle all day, so the light was flat but soft and uniform. I spent several hours walking aimlessly up and down the beach, looking for interesting patterns on the ground. I didn't find anything other than the odd shell here and there, which I ended up collecting in my pocket. Finally, I spotted this rock formation, into which I carefully placed my shells. I sprinkled some sand sprinkled on top and placed a single shell a little way from the others.
Camerawork: Linhof Technikardan with Schneider Apo-Symmar 210mm lens, Velvia 50, four seconds at f/32.
Post capture: Scanned on an Imacon Flextight, with a shallow S-curve applied to enhance local contrast.

On reflection: *There's something of a taboo surrounding the notion of interfering with the natural landscape – but I enjoyed breaking it! This image is entirely staged, but retains a sense of the natural world about it.*

Inspiration: I was mainly drawn to the scene by the prospect of lunch, I recall, and to lie down in an attempt to get below the ferocious Chilean wind. This bush, called llareta, is a very attractive feature of the southern Chilean landscape. It hugs the ground for the very same reason that I did. The bleached log appears recumbent upon what appears to be the springy mattress of the bush.
The situation: I was difficult to simplify the elements of the scene. There were items just outside the frame that would have detracted from the two main elements of log and bush and a number of conjuring tricks were needed in order to achieve the simplicity I craved. In hindsight, a course in yoga may have been beneficial.
Camerawork: Minolta Dynax 700si with 28-105mm lens, Velvia 50, exposure not recorded, Gitzo tripod with Manfrotto head.

On reflection: *I tend to compose most of my images in the portrait format, but on this occasion I felt the landscape format suited the central log and bush with the lines, suggestive of rivulets, flowing backwards.*

p119

p120

PHOTOGRAPHERS' BIOGRAPHIES

NIALL BENVIE

Niall has worked as a professional outdoor photographer and writer since graduating from Dundee University in 1993, following an earlier career as a fruit farmer. His special interest is in the nature/ culture dynamic. He has a passion for using photographs and photography as a way of introducing people to the wonder of the natural world. His initiatives include Rewilding Childhood, Meet Your Neighbours, the Scottish Nature Photography Fair and Photographers For Latvia, and he writes regularly on nature photography and cultural topics. He was a founding director of Wild Wonders Of Europe, a founding fellow of the International League Of Conservation Photographers and is on the team of 2020Vision. His most recent book, *Outdoor Photography Masterclass*, was published in 2010.

• niallbenvie.com

JOE CORNISH

Joe Cornish has been a working photographer for 30 years. After assisting photographers in Washington and London, he began his career as a travel photographer doing guidebooks on regions of Europe. He eventually contributed photography to more than 30 books. His first book for the National Trust (*In Search Of Neptune*) led to a long-term association with that organisation and a focus on landscape and the environment. In the late 1990s he began writing articles for magazines, and in 2002 his first book as an author, *First Light*, was published. *Scotland's Coast* and *The Northumberland Coast* have followed. He has lectured extensively in the UK and led workshops for Light & Land, and Inversnaid Photo. He is a co-director of the Joe Cornish Gallery in Northallerton in North Yorkshire. His most recent book is *Scotland's Mountains: A Landscape Photographer's View* (Aurum, 2009). He is an Honorary Fellow of the Royal Photographic Society.

• joecornish.com

PAUL HARRIS

Paul has been a photographer for more than 20 years and specialises in people, nature and adventure travel. Engagement and curiosity have been at the heart of his worldwide documentary projects, whether they involve riding horses across the steppes of Mongolia, sailing traditional dhows through the Malay archipelago or enjoying the hospitality of theology students on the Iranian border. He has been photographer-in-residence for The Royal Geographical Society and Earthwatch Europe. His seminal portraits of British explorers are in the National Portrait Gallery collection and he was awarded the Geographical Society's Cherry Kearton medal for photography of 'Peoples and the natural world'. Recent assignments working with Earthwatch in Kenya and Tanzania, Coral Cay in Fiji and the Philippines and The National Trust across the UK have continued his passion for the environment. He currently writes a regular column for *Outdoor Photography* magazine.

• paulharrisphotography.com

PHIL MALPAS

Phil Malpas is a freelance photographer and writer based in Swindon, Wiltshire. He was previously a director of Photofolio, a commercial gallery in the north of England, and is a regular contributor to a variety of magazines and journals. Working with both large-format and digital cameras, Phil teaches photographic technique both locally and by leading photographic tours around the world for Light & Land, for whom he has led more than 40 tours. Phil's first book, Capturing Colour, was published in November 2007 and he has recently followed this up with the third book in the Light & Land series, *Finding The Picture*, which was co-written with his good friend and fellow tour leader Clive Minnitt, and published by Aurum in 2009.

• philmalpas.com

CLIVE MINNITT

After working in the IT industry for many years, Clive moved into full-time photography in 1997. Since then he has established a reputation as one of the leading photographers in the UK. Clive's work has been widely exhibited including at Christie's and the Mall Galleries in London, in addition to Cardiff's St David's Hall. He has also completed commissions for a diverse range of clients including Sun Life Assurance, and the Bristol Cancer Help Centre. Both Fuji and Panasonic have used his images to advertise their own products. He leads photographic holidays to many different locations throughout the world. Many magazines and books have featured Clive's work and he currently has a regular column in *Outdoor Photography* magazine. His first book, *Clevedon Pier: A Celebration Of England's Finest Pier*, was published in 2008. This was followed in 2009 by *Finding the Picture*, which was co-written with Phil Malpas.

• minnitt.co.uk

BEN OSBORNE

Ben Osborne specialises in wildlife, landscape and environmental subjects. He won the Shell Wildlife Photographer Of The Year Competition in 2007. In 2008 he was awarded an Honorary Fellowship by the Royal Photographic Society. He has contributed to numerous magazines, including National Geographic, and has shot production stills for several major BBC wildlife series, including *Life in the Freezer*, *Blue Planet* and *Planet Earth*. He has toured his audiovisual presentations about these journeys to more than 500 venues. More recently he teamed up with musicians and poets to produce a mixed-media presentation about the rivers Severn and Wye, and is following that with a similar project on the Jurassic Coast. He provided visual material for Darwin's Dream, an opera about Darwin and evolution, which was staged in the Albert Hall. He runs photographic tours, workshops and seminars for all ages and abilities.

• benosbornephotography.co.uk

DAVID WARD

David Ward has photographed commercially a wide variety of subjects from dogs to racing cars, but his first love remains the landscape. Working with a large-format camera, he has spent the last 20 years lugging 20 kilos of gear up fells at decidedly unsociable hours in search of that special moment to immortalise on film. He has travelled and photographed throughout the UK and beyond to Canada, the Colorado Plateau, Iceland, Norway, France and many other locations. Working to commission on walking and travel guides in the UK, he contributed to nearly 20 books in the 1980s and early 1990s. His recent personal work concentrates more on intimate details than the wide vista. He has written two critically acclaimed books on landscape photography: *Landscape Within* (2004) and *Landscape Beyond* (2008). David's wide range of skills, acquired as a location photographer working in advertising, design and publishing, are now being passed on to fellow lovers of the landscape through his workshops with Light & Land.

• into-the-light.com

CHARLIE WAITE

Charlie Waite was born in 1949 and worked in British theatre and television for the first ten years of his professional life. During this time he became fascinated with the landscape, and began to develop the photographic style that characterises his work today. Nowadays, his photographs are held in private and corporate collections throughout the world. Over the last 25 years, he has lectured throughout the UK, Europe and the US, and has held numerous one-man exhibitions in London, Tokyo, Carmel California and New York. In September 2005, Charlie filmed a six-part television series on landscape photography. He has published more than 20 books on photography, including *In My Mind's Eye*, his first book of black-and-white photography; and Landscape: *The Story Of Fifty Favourite Photographs*. In 2007 Charlie launched Take A View, an annual photographic award to find the UK's 'Landscape Photographer Of The Year', which ties in perfectly with his desire to share his passion for, and appreciation of, the beauty of our surroundings through photography.

• charliewaite.com

First published in 2010 by Argentum, an imprint of Aurum Press Limited, 7 Greenland Street, London NW1 0ND

A catalogue record for this book is available from the British Library.

ISBN 978 1 902538 59 4

Designed by Eddie Ephraums

Printed in Singapore